MW00608895

POSTCARD HISTORY SERIES

Seaside Heights

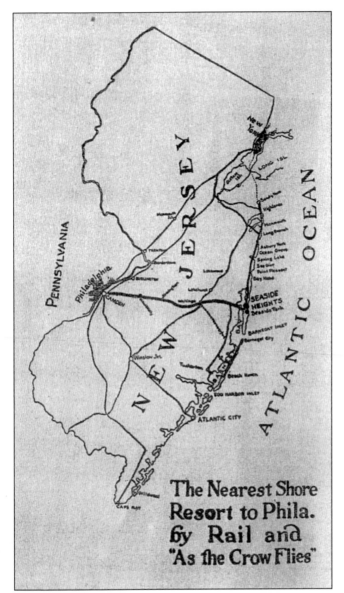

The Nearest Shore
Resort to Phila.
6y Rail and
"As the Crow Flies"

This map of New Jersey was the back cover of a sales brochure distributed by Clyde G. Marcy, "The Pioneer Builder," soon after 1915. Marcy's marketing piece explained the benefits of buying a vacation cottage or year-round home in Seaside Heights: good streets, pure water and artificial ice from artesian wells, an up-to-date public school, three hotels, public beach pavilion, concrete sidewalks, yacht club, and a carousel. (Courtesy of Leonard Ipri.)

ON THE FRONT COVER: The postcard that appears on the front cover of this book, from the white-bordered era of postcards (1915–1930), shows Freeman's Amusement Center soon after Danceland opened in 1922. The roots of the amusement industry in Seaside Heights can be traced precisely to the carousel that was housed inside Freeman's pavilion.

ON THE BACK COVER: In this view, a lifeguard, who is standing toward the left side of this postcard with his arms folded, keeps watch over bathers who have ventured out into the ocean for a sea bath. Vacationers are wearing the bathing costumes of the day, following proper beach etiquette.

POSTCARD HISTORY SERIES

Seaside Heights

Christopher J. Vaz

ARCADIA
PUBLISHING

Published by Arcadia Publishing
Charleston, South Carolina

Printed in the United States of America

Library of Congress Control Number: 2009935822

For all general information contact Arcadia Publishing at:
Telephone 843-853-2070
Fax 843-853-0044
E-mail sales@arcadiapublishing.com
For customer service and orders:
Toll-Free 1-888-313-2665

Visit us on the Internet at www.arcadiapublishing.com

This book is dedicated to my mother, Mary Ellen Vaz, and father, Dr. Anthony E. Vaz. You have given me unconditional love and support over the years without ever asking for anything in return. You are also responsible for passing down to me the "Seaside Heights gene." For those reasons and many more, I shall always be grateful.

And also to my wife and best friend, Andrea, who everyday strolls with me down the boardwalk of life . . . Thank you, Widgee.

CONTENTS

ACKNOWLEDGMENTS

This book would not have been possible without the support of my family and many friends and acquaintances. I am indebted to all of you.

I am especially grateful to Leonard Ipri who shared with me many awesome vintage photographs of Seaside Heights and memories that helped complete my research. I am honored that he trusted me with possession of his personal collection. Sadly, Leonard passed away at the age of 89 several months before this book was published. There is a great loss in my heart as Leonard was a friend and fellow member of the Seaside Heights Volunteer Fire Company. However, his death also was a great loss for the Seaside Heights community. Leonard loved Seaside Heights immensely and cared very much about preserving its history. One of his legacies is the Seaside Heights Volunteer Fire Company Museum, which he designed, constructed, and helped maintain.

Thank you to Tommy Reutter for spending time with me perusing my postcards and sharing information. Tommy is the definition of *gentleman*.

I also thank the following persons and organizations for providing assistance and encouragement during this project: Dr. Floyd L. Moreland; Dr. Anthony E. Vaz; Guy Mazzanti; Bob Iasillo; Arthur Fierro; Peter Smith; Jessica Paola; Richard and Alma Chabok; Theawna M. Brown; Betsy Dudas; Kim Pascarella, Esq.; Estate of Belle Freeman; Seaside Heights Volunteer Fire Company; Ocean County Historical Society; Ocean County Library; and the New Jersey State Archives. I give special recognition to my high school friend Megan Brady. I learned during the course of researching this book that Megan is the granddaughter of Louis and Stella Blazik, who were much admired residents of Seaside Heights before they passed away. Megan took an interest in this book—from many miles away where she resides in Kentucky—and loaned me a postcard collection that was passed down to her from her grandfather.

To Arcadia Publishing and its team, especially my editor, Erin Rocha, thank you for taking care of my postcards, giving attention to my words and ideas, and for publishing such extraordinary books.

And last, but not least, thank you to my wife, Andrea, and our daughters, Rhiannon and Mackenzie. They accompanied me, without protest, to libraries and many postcard and collectible shows during the two years of research for this book. I am not forgetful of the fact that every hour and day I spent in the basement working on this project was a precious hour and day not spent with you.

Unless otherwise noted, all images are from the author's collection.

INTRODUCTION

I first met Arthur Fierro in 1992. By that time, Arthur's family had vacationed in Seaside Heights for 70 years and owned property in the town for over 50 years. Although Arthur was nearly three decades older than me, a friendship was born that was based on our shared admiration for Seaside Heights and its history. We spent countless hours discussing the glory days of Seaside Heights. I described for Arthur childhood memories of buying nails with my father at McDevitt's Hardware Store, eating at the Humpty-Dumpty Restaurant, stopping by Finn's 5¢ and 10¢ Store virtually every day for chewing gum, swimming at the saltwater pool, and picking up my mother's weekly order of Genoa salami and cheese from the Heights Food Market, which was located only steps away from our home at 119 Franklin Avenue.

Arthur had his own knowledge and memories to share, some of which were handed down to him by family members. I was awestruck by his descriptions of how the bay front had stopped at Bay Boulevard before the state's highway improvement project in the 1950s. He spoke of an era when the original Bamboo Bar and, later, the Parrot Club offered nightly dancing to music performed by a live orchestra. During World War II, the Jersey Shore boardwalks and beaches, including those in Seaside Heights, were subject to a blackout between sunset and sunrise that was intended to cut off as much light as possible so that German U-boats would have a difficult time finding targets. Seaside Heights even had roller rinks and bowling lanes!

Fast forward to summer 2007 . . .

I was given a copy of Arcadia Publishing's *Browns Mills*, written by Marie F. Reynolds, and I decided after reading it that I would write a similar book about Seaside Heights using postcards and whatever photographs I could get my hands on.

As I started to amass hundreds of postcards from different time periods, my conversations with Arthur 15 years earlier came to life through the spectacular postcards that I was finding at postcard and collectible shows in New York and Pennsylvania and closer to home in Ocean Grove and Belmar, New Jersey.

I found an ancient microfilm reader that someone sold me for $5, and I purchased a dozen reels of *New Jersey Courier* and *Ocean County Review* microfilm from the New Jersey State Archives. In a short time, the history of Seaside Heights was unfolding before me.

Then, as my research progressed, memories from my own childhood started to come out from their hiding places. There were memories of after-school stickball games with Reece Fisher and Dana Spencer at an empty sand lot on Sumner Avenue, folding towels for a nickel a dozen at Mike Graichen's towel and comforter stand at Webster Avenue and the Boardwalk, fishing and crabbing the bay with Kevin Arnold from the south pier, and hanging out with George Shenewolf on the boardwalk for our ritual of running from arcade to arcade, hunting for quarters left behind in change slots so we would have money to play pinball late into the night.

Through this process, it finally occurred to me that although dates and places are certainly important to a local history book, the proper telling of my hometown's history involves what we remember and preserve about the people who built lives here, their children, their children's children, and so on.

Thus, I introduce Seaside Heights to you with a request that you think about your own relationship to the town. Did you live here? Visit here? Work here? Do you have any personal connections to Seaside Heights, perhaps to some of the people and images that are presented in this book?

The history of Seaside Heights is an enduring and continuously expanding collection of the lives and experiences of its people!

I am very interested to hear from people who have their own Seaside Heights stories to recount or who have photographs and memorabilia to share. Please contact me directly via e-mail at christopherjvaz@aol.com.

One

THE ADVENT

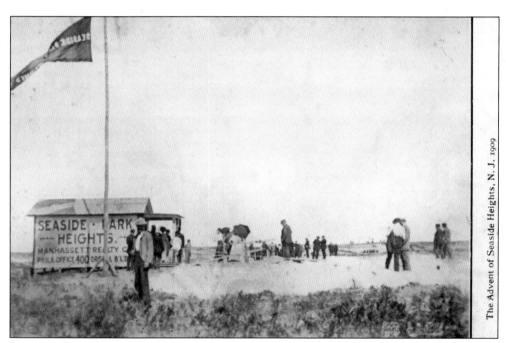

The Advent of Seaside Heights, N. J. 1909

In 1908, the section of barrier island that would become Seaside Heights was still known as North Seaside Park. The area was little more than an expanse of sand dunes and poison ivy. The extraordinary vision to promote a resort here was conceived when members of the Grosscup family formed the Manhassett Realty Company in 1909 and acquired beachfront property that was plotted into 855 lots, each 40 feet wide.

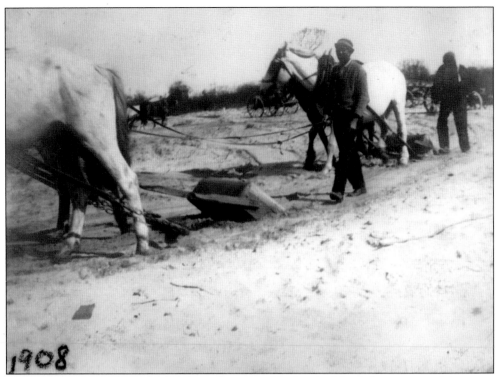

There were two other tracts on this maturing part of the barrier island. A prosperous fishery was located on the Larkin Tract, the land between Grant and Sherman Avenues near the oceanfront. The second was owned by the Cummings brothers and consisted of the land north of Sherman Avenue. The above photograph, taken in 1908, shows the laborious process of making streets and curbs using horses and scoops. (Courtesy of Leonard Ipri.)

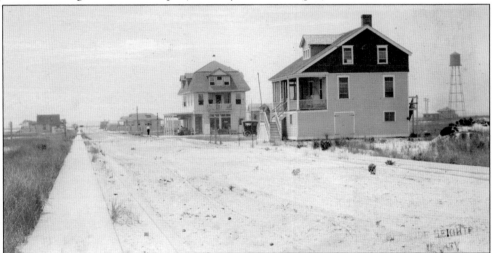

This is an early view of the Sumner Hotel looking toward the bay. Out-of-towners were tempted to visit the emerging resort on train excursions sponsored by Manhassett and other realty companies. After the excursionists arrived, they were provided a meal at the Sumner Hotel while enjoying the music of a three-piece orchestra. Afterward, they were marched down to the lots for their sales presentations.

10

The water tower owned by the Peninsular Water Company rises high above one of the first homes constructed in the new seaside development. In July 1915, the voters decided in favor of buying the water plant and also of building an electric plant at the same location by issuing a $50,000 bond.

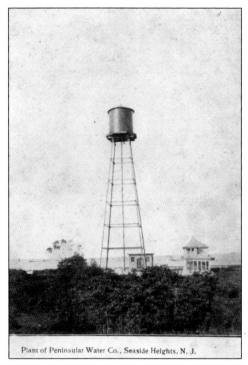

Plant of Peninsular Water Co., Seaside Heights, N. J.

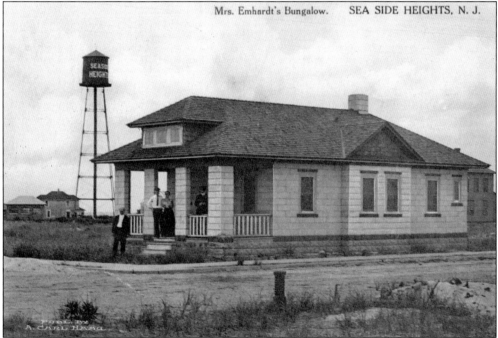

Mrs. Emhardt's Bungalow. SEA SIDE HEIGHTS, N. J.

Postmarked in 1916, this card shows Mrs. Emhardt's bungalow with the water tower standing tall in the background. In the spring of 1927, the tower and $100 were promised to J. Stanley Tunney for taking down the structure, which had been declared a nuisance. A dispute arose and Tunney had to fight the town for his money, but he later became one of the town's most influential businessmen and served as mayor between 1940 and his death in 1964.

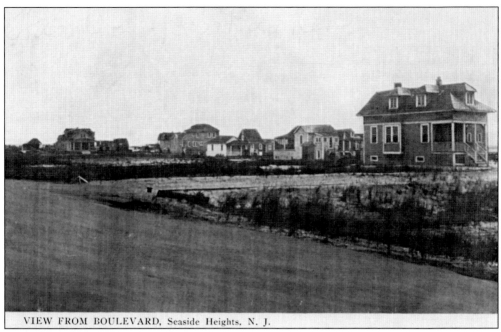

VIEW FROM BOULEVARD, Seaside Heights. N. J.

Early homes lacked the convenience of a modern toilet. Instead, most dwellings had a privy in the rear yard. In this view, a privy is visible to the left of the house in the right foreground. Privies became obsolete after the borough council installed sanitary sewers throughout the town and a treatment and disposal plant in the late 1920s.

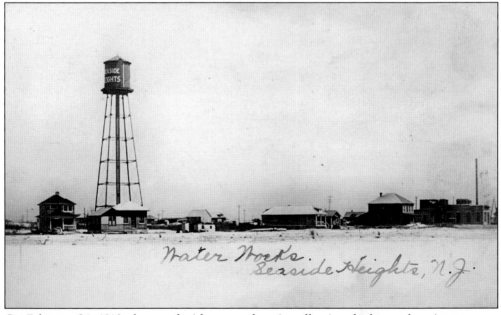

On February 26, 1913, the state legislature took action allowing the borough to incorporate. One month later on March 25, at the Sumner Hotel, a referendum was held on separating from Berkeley Township and forming a new town. The question received the unanimous support of all 21 people who voted. The independence of the new borough is proclaimed in this postcard by the words "Seaside Heights" prominently painted on the water tower.

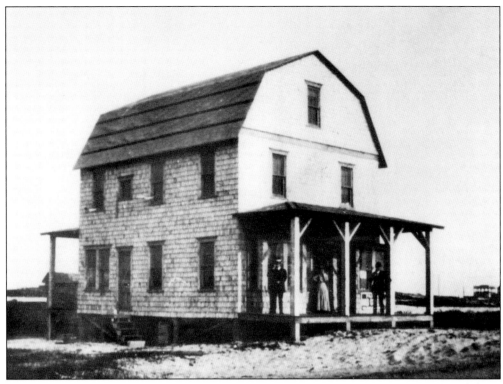

The Duggan House, at Hancock Avenue and the Boulevard, was said to be the oldest dwelling in Seaside Heights until it was leveled in the 1970s by a natural gas explosion. Numerous proprietors operated the building over the years as a hotel, restaurant, and grocery store. The property was inherited in 1945 by Maria Duggan's nephew, Martin Heffernan, who operated the Heffernan Real Estate Office there. (Courtesy of Leonard Ipri.)

This card shows the home of Dr. Howard Dager on Sumner Avenue near the oceanfront. Dr. Dager served on the first board of health that was organized in 1914.

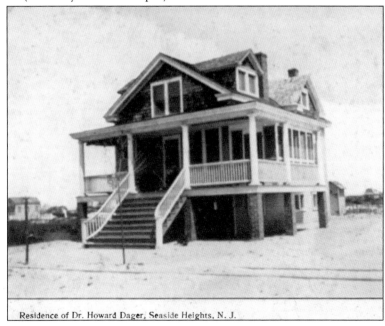

Residence of Dr. Howard Dager, Seaside Heights, N. J.

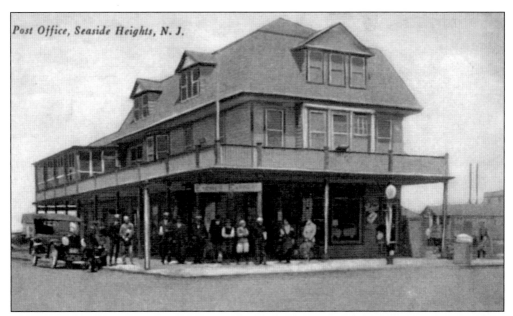

Post Office, Seaside Heights, N. J.

By spring of 1914, the Sumner Hotel operated so profitably that its proprietor, Joseph Endres, erected an addition to the building that included a large dining room and sitting room. The hotel also housed the post office and a store that carried groceries, furnishings, glassware, china, hardware, toys, tobacco, patent medicines, and soft drinks. A sign stating "Endres Express" hangs from the deck at the corner of the building.

These early homes on Blaine Avenue, near the oceanfront, were built in approximately 1916. The two nearest lots are not filled in around their foundations. Many lots in those days were 3 or 4 feet below the grade of the street. It was common for home owners to have to wait for storms and the forces of nature to carry in sand to fill the lots. (Courtesy of Leonard Ipri.)

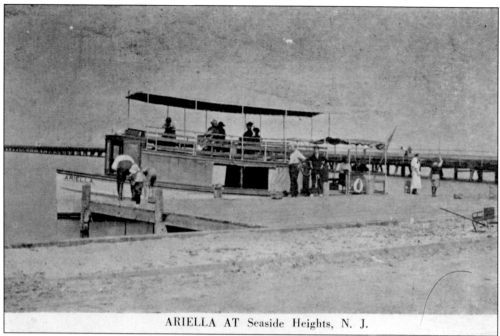

ARIELLA AT Seaside Heights, N. J.

Lambert's Excursion Line, owned by Capt. Ira C. Lambert, operated the *Ariella* and *Dorianna* between Toms River and Seaside Heights. The boats traveled separate eastward and westward routes with stops in Pine Beach, Island Heights, Ocean Gate, and Seaside Park. The first residents used the boats to travel to the mainland to shop, visit friends, and to see a doctor or dentist. This postcard shows the *Ariella* alongside the dock in Seaside Heights.

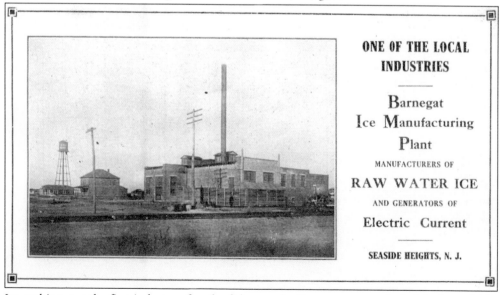

ONE OF THE LOCAL
INDUSTRIES

Barnegat
Ice Manufacturing
Plant

MANUFACTURERS OF

RAW WATER ICE

AND GENERATORS OF

Electric Current

SEASIDE HEIGHTS, N. J.

Ice making was the first industry after the fish pounds. Twenty men worked eight-hour shifts. The plant could hold 100 tons of ice and had a freezing tank with capacity for making 30 tons a day. Christian Hiering, one of the town's first residents, was chief stockholder of the Barnegat Ice Manufacturing Company and is credited with the plant's construction and early success. (Courtesy of Leonard Ipri.)

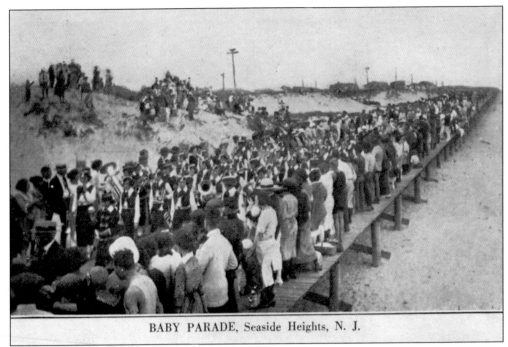

BABY PARADE, Seaside Heights, N. J.

The marching band from the John Wanamaker Commercial Institute Summer Camp in Island Heights leads this early baby show and parade. The procession started at Sumner Avenue and proceeded to the carousel on Dupont Avenue. Prizes were awarded for the handsomest baby, the fattest baby, and the cutest baby. The entry fee was 35¢, but every mother and baby received a free ride on the merry-go-round and a souvenir.

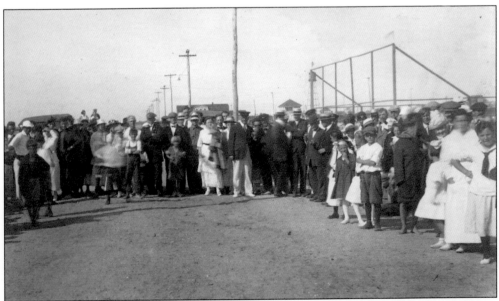

The occasion for this real-photo postcard is unknown, but one guess is that this group of finely dressed adults and children was visiting Seaside Heights as part of an excursion sponsored by either Manhassett Realty Company or Cummings Realty.

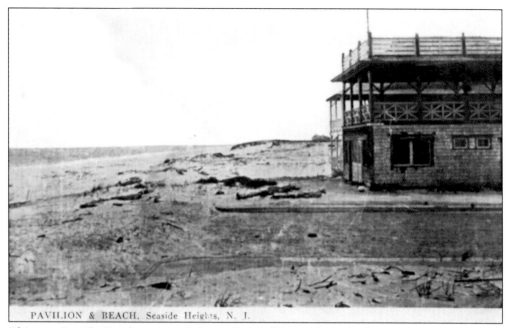

PAVILION & BEACH, Seaside Heights, N. J.

This rare Seaside Heights postcard shows the pavilion at the end of Sumner Avenue that was initially used by the Manhassett Realty Company to entertain potential land purchasers. Of note is that the street comes to an end right at the beach, which at that time remained undeveloped. The boardwalk had yet to be constructed, and sand dunes can be seen dotting the beach south of the pavilion.

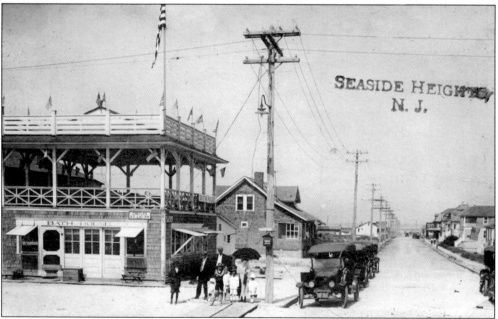

A family stands in front of the pavilion, which is decorated with American flags. The bathhouse was located on the first floor and provided accommodations for visitors to change into their bathing costumes. Tables and chairs were set up on the second-floor deck, which was often used as a bandstand for concerts and dancing.

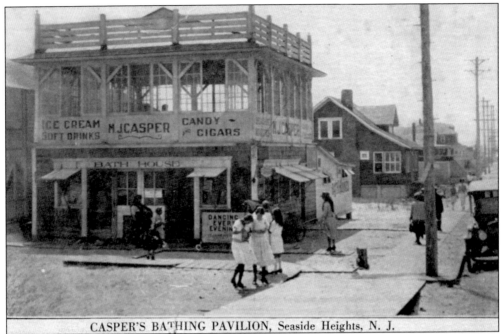

CASPER'S BATHING PAVILION, Seaside Heights, N. J.

The pavilion opened in 1921 under the ownership of Marvin Casper. Marvin Casper was well liked by the children and affectionately called Pop. It was not uncommon for Pop to add extra ice cream on each pint, quart, or double-decker cone.

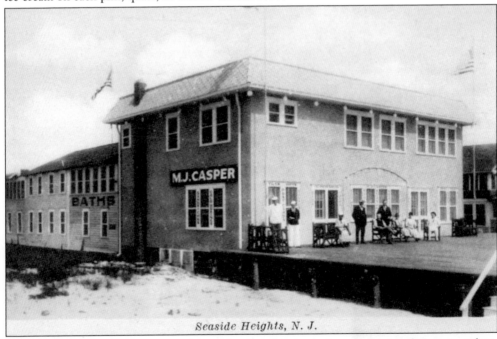

Seaside Heights, N. J.

Casper's Bathing Pavilion was reconstructed and modernized when this postcard view was taken. An advertisement in the *Ocean County Review* stated that, in addition to the bathhouses for hire, Casper's Bathing Pavilion sold bathing suits, toilet articles, drugs, stationery, toys, novelties, caps and shoes, belts, beads, jewelry, ice cream, and iced soft drinks.

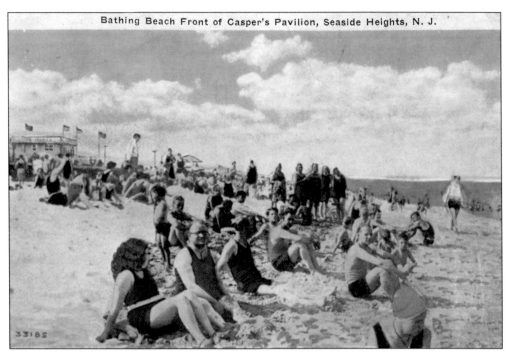

Bathing Beach Front of Casper's Pavilion, Seaside Heights, N. J.

The ocean has always been the enticement that attracts large crowds to Seaside Heights. In this scene, numerous sea bathers are sitting or standing on the beach at Casper's Bathing Pavilion.

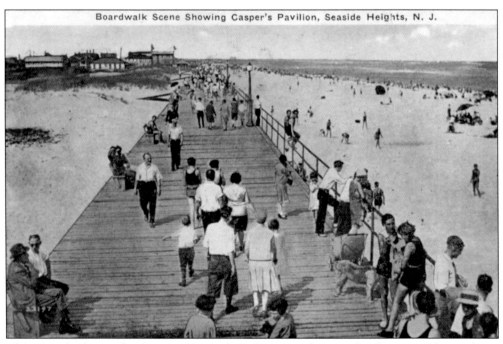

Boardwalk Scene Showing Casper's Pavilion, Seaside Heights, N. J.

This view looks north, showing Casper's Bathing Pavilion in the distance. The card was postmarked on May 26, 1930. Note the two people on the second bench who are shielding their eyes from the sun. Other people in this view, including the two boys sitting on the railing, are also looking toward the photographer.

19

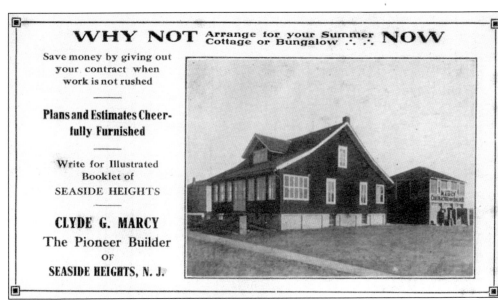

Clyde G. Marcy, who is mentioned in other captions in this book, was one of the first local builders in Seaside Heights. Other early builders included Mayor Edmund C. Kramer, N. E. Rex, J. C. Tindall, C. Milton Stimus, Wilfred G. Gaiter, and R. M. Milne. (Courtesy of Leonard Ipri.)

A young girl sent this postcard in 1914 to family friends in Newark, New Jersey. On the reverse side she wrote, "I am having a good old time and wish you were with me. Love to all and you. From your little friend, Ella May."

Two

THE HAMILTON AVENUE GATEWAY

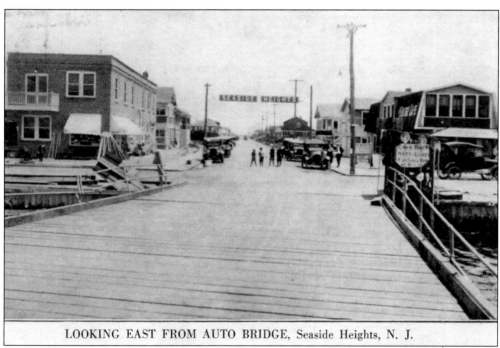

LOOKING EAST FROM AUTO BRIDGE, Seaside Heights, N. J.

After the wooden toll bridge constructed by the Island Heights and Seaside Park Bridge Company opened to the public in 1915, the Hamilton Avenue and Bayview Avenue intersection was transformed into a gateway for mainlanders traveling to Seaside Heights and Seaside Park and points north such as Lavallette and Point Pleasant. The Bridge Café, which was completed in October 1914, is on the corner at the right side of the postcard.

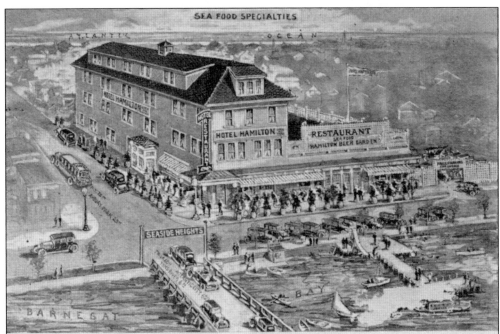

HOTEL HAMILTON and Restaurant, at the bridge, Seaside Heights, N. J. Phone 148

This rare advertising postcard shows the Hotel Hamilton and Restaurant at the entrance to the auto bridge. Note also the sign for the Hamilton Beer Garden. The card's theme emphasized the proximity of the hotel to the Barnegat Bay and public dock, with its fleet of pleasure boat rentals and opportunities for swimming, fishing, and crabbing.

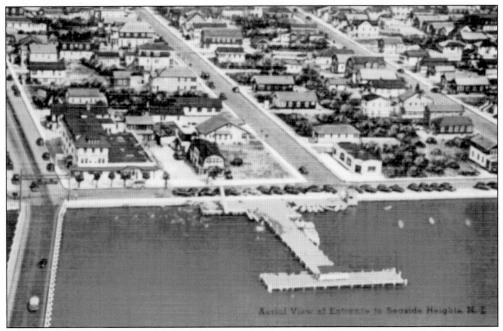

This aerial view of the entrance to Seaside Heights looks east. Franklin Avenue and Lincoln Avenue are to the right of the public dock.

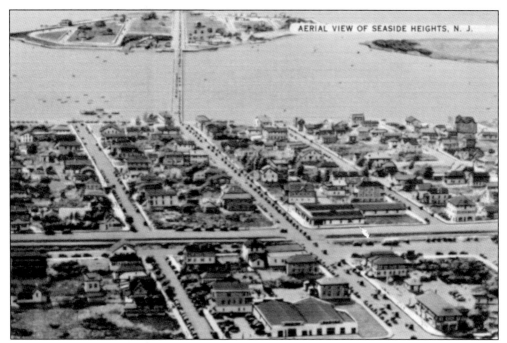

An interesting detail in this postcard is that, unlike Hamilton Avenue, neither Franklin Avenue nor Webster Avenue was opened across the railroad tracks. Also, the large building at the bottom center of the card was the Heights Food Market operated by Tommy Reutter and Martin P. Scharf. Reutter served as a borough councilman for more than 25 years. Both Reutter and Scharf were members of the Seaside Heights Volunteer Fire Company.

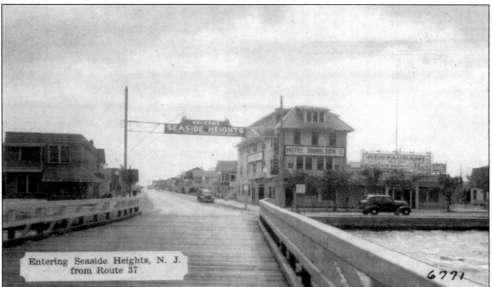

This real-photo postcard shows the main gateway into Seaside Heights in the early morning. Travelers could cross the auto bridge onto Hamilton Avenue and turn left at the Boulevard for a 75-mile trip to New York City or a 20-mile trip to Asbury Park. Philadelphia and Atlantic City were both 60 miles in the other direction. Downtown Toms River was a mere 6.2 miles to the west.

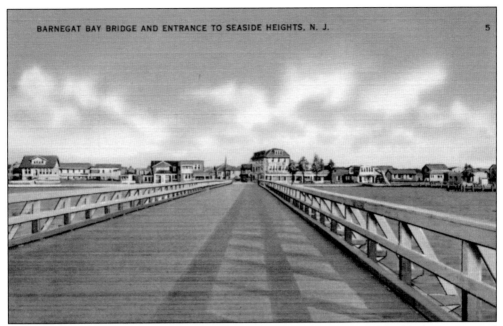

The wooden handrail is casting a shadow in this view. This part of the bridge connected Pelican Island to Seaside Heights. The longer stretch of the 2-mile bay bridge linked Pelican Island with the mainland.

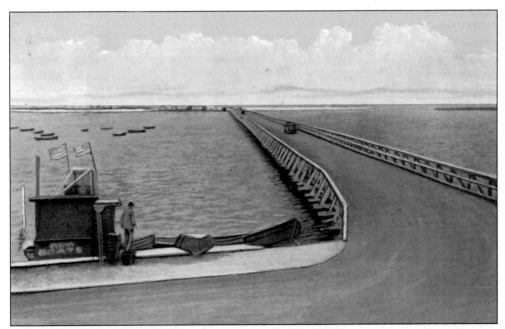

Entitled "Showing Pelican Island," this postcard was postmarked on June 17, 1929. The view looks west to the island from an area in front of the Hotel Hamilton. A close examination of the undeveloped north side of the island reveals the channel that divides Pelican Island from the uninhabited sedge islands even to this day.

24

Three

THE BAY BRIDGE

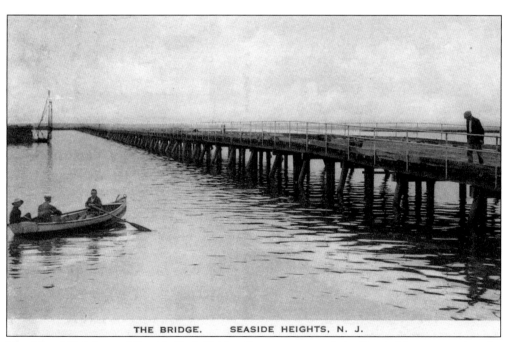

THE BRIDGE. SEASIDE HEIGHTS, N. J.

The Island Heights and Seaside Park Bridge Company owned the first bridge connecting the Toms River mainland with the barrier island. The bay bridge reduced the road distance from Toms River to Seaside Heights from 30 miles (via the Mantoloking Bridge) to 6 miles. Perhaps more importantly, the bridge established Seaside Heights and its beaches as the nearest resort to Philadelphia of any resort on the New Jersey coast.

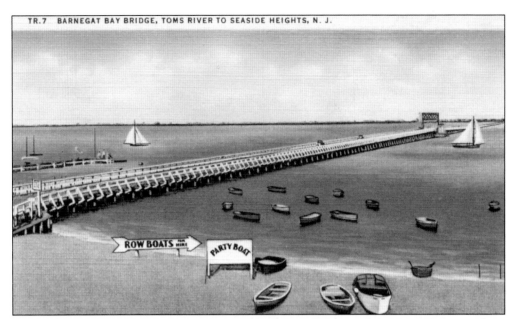

The bridge tender's quarters and tollhouse and the iron draw can be seen in this view from Toms River to Seaside Heights. Tolls were as follows: carriage with one horse and driver, light or loaded, 15¢; carriage with two horses and driver, light or loaded, 30¢; automobile and driver, 25¢, and additional passengers 5¢ each; pedestrian, 5¢; motorcycle with driver, 15¢; and each horse, cattle, hog or sheep, led or in droves, 10¢.

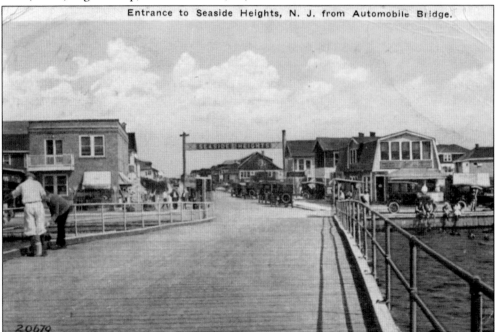

Entrance to Seaside Heights, N. J. from Automobile Bridge.

The old plank bridge was made of creosoted timbers that would often catch fire, requiring the assistance of the Seaside Heights Volunteer Fire Company to douse the flames. At other times, storms caused waves to surge across the bridge, scaring travelers from making the crossing until the poor weather subsided.

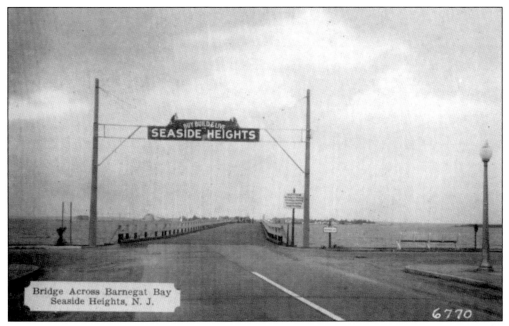

The bay bridge was 198 feet short of being 2 miles long. Across Pelican Island and for some distance to the west from the island, the bridge was replaced by a gravel road, built with fill from dredging the bay.

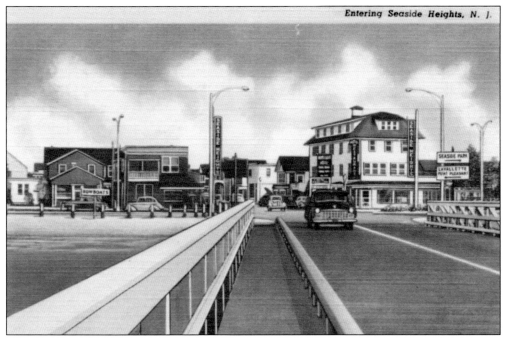

The bay bridge was renovated by the State of New Jersey between November 1926 and May 1927. The new bridge was wider and had clearly distinguishable eastbound and westbound lanes. Additionally, as seen in this view, a pedestrian walk was added on the north side of the bridge.

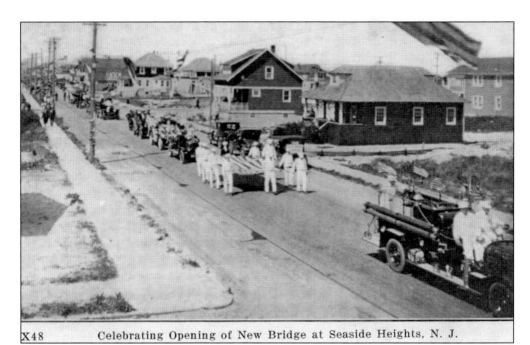

X48 Celebrating Opening of New Bridge at Seaside Heights, N. J.

The State of New Jersey purchased the bridge in 1922 and abolished the tolls. After an extensive reconstruction, the bridge officially reopened on May 28, 1927, with a 7-mile-long parade. The procession started on Main Street in Toms River, proceeded to Washington Street, and then continued over the bridge. After advancing east on Hamilton Avenue, the parade turned south. The Boy Scout Band of Trenton led the parade, followed by dozens of state and local officials, bands, Boy Scout troops, schoolchildren, floats, and automobiles advertising county businesses. The highlight of the parade was the 21 volunteer fire companies, whose members wore their dress uniforms and marched in front of hundreds of passenger automobiles. The procession ended in Seaside Park, where visiting firemen were royally entertained at a carnival arranged by a joint committee of the Seaside Heights and Seaside Park Volunteer Fire Companies.

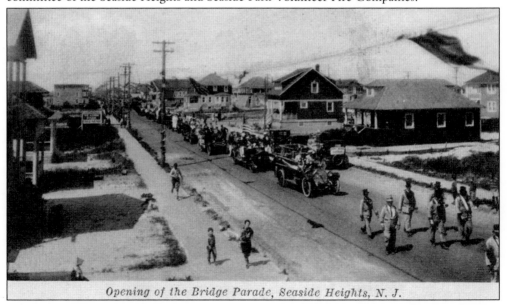

Opening of the Bridge Parade, Seaside Heights, N. J.

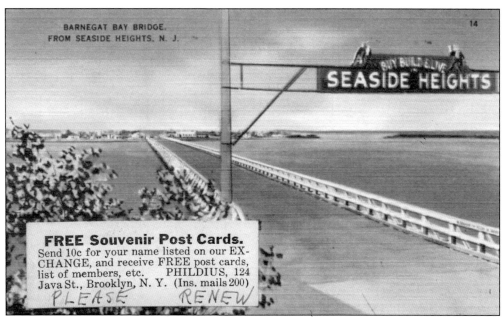

BARNEGAT BAY BRIDGE.
FROM SEASIDE HEIGHTS. N. J.

14

SEASIDE HEIGHTS

FREE Souvenir Post Cards.
Send 10c for your name listed on our EX-
CHANGE, and receive FREE post cards,
list of members, etc. PHILDIUS, 124
Java St., Brooklyn, N. Y. (Ins. mails 200)

PLEASE RENEW

Clyde G. Marcy built many of the early homes in Seaside Heights and constructed the town's first elementary school. He served as the town's first borough clerk and later as tax collector. He was also a member of the Seaside Heights Volunteer Fire Company. Marcy was described as very intelligent—"a walking dictionary." He moved to Seaside Heights in 1911, leaving a job as a high school principal in northern Pennsylvania for an outdoor life as a building contractor. But the labels on the front and back of this postcard confirm a fascinating piece of information about Marcy that is not found in the public records. Marcy was a passionate postcard collector. There can be no doubt that Marcy's postcard hobby had a lot to do with introducing Seaside Heights to people from all over the country.

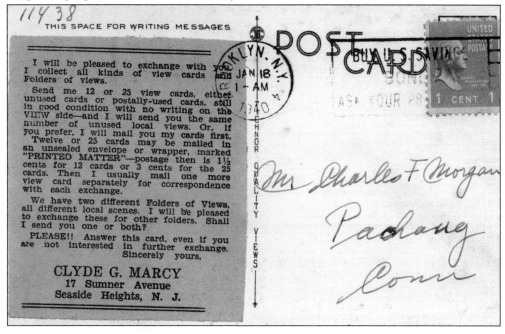

THIS SPACE FOR WRITING MESSAGES

I will be pleased to exchange with you.
I collect all kinds of view cards and
Folders of views.
 Send me 12 or 25 view cards, either
unused cards or postally-used cards, still
in good condition with no writing on the
VIEW side—and I will send you the same
number of unused local views. Or, if
you prefer, I will mail you my cards first.
 Twelve or 25 cards may be mailed in
an unsealed envelope or wrapper, marked
"PRINTED MATTER"—postage then is 1½
cents for 12 cards or 3 cents for the 25
cards. Then I usually mail one more
view card separately for correspondence
with each exchange.
 We have two different Folders of Views,
all different local scenes. I will be pleased
to exchange these for other folders. Shall
I send you one or both?
 PLEASE!! Answer this card, even if you
are not interested in further exchange.
 Sincerely yours,

CLYDE G. MARCY
17 Sumner Avenue
Seaside Heights, N. J.

POST CARD

Mr Charles F Morgan
Padang
Conn

29

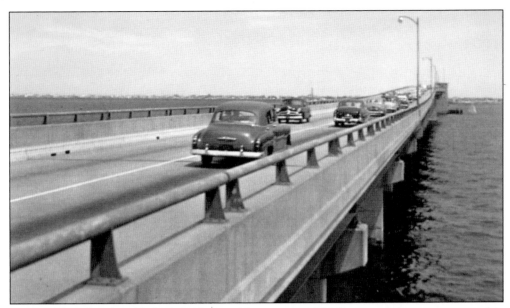

Recognizing that the old plank bridge could not cope with the growth in summer vacation travel to Seaside Heights, the state constructed a new steel and concrete bridge, costing nearly $7 million, 37 feet south of the original wooden bridge. Gov. Alfred E. Driscoll dedicated the new mile-long bridge on May 24, 1950, and he ceremoniously signed legislation naming the new structure the Thomas Mathis Bridge.

Thomas Mathis Bridge, over Barnegat Bay, Seaside Heights, N. J.

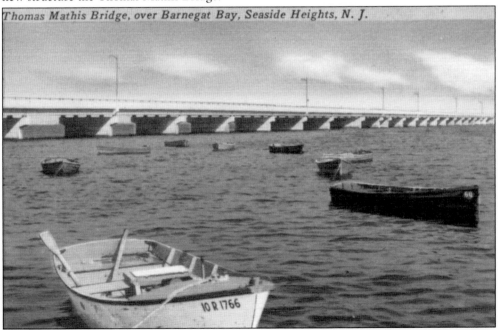

Present-day travelers to Seaside Heights will observe that the three lanes on the Mathis Bridge are unusually narrow. The reason for this is that after the westbound Stanley Tunney Bridge opened in 1972, the locals realized that three lanes were taking people out of Seaside but there were only two inbound lanes. To remedy the inequity, the Mathis Bridge lanes were repainted and made narrower to accommodate a third inbound lane.

Four

THE BAY SHORE

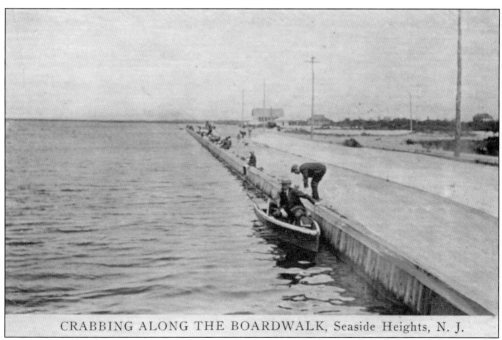

CRABBING ALONG THE BOARDWALK, Seaside Heights, N. J.

Postmarked in 1919, this view card shows numerous people fishing and crabbing along the mostly undeveloped bay front area. Although the locals knew better and wore their regular clothing while engaging in the messy business of fishing, it was not unusual for visitors from the cities to fish and crab in their finery, wearing top quality suit jackets with trousers and fancy hats.

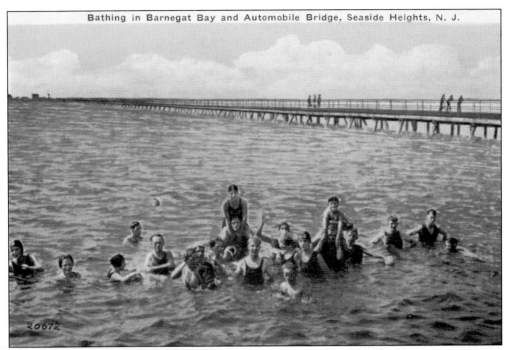

Bathing in Barnegat Bay and Automobile Bridge, Seaside Heights, N. J.

This postcard attests that the large expanse of ocean just four blocks to the east was not the only water recreation in Seaside Heights. Barnegat Bay on the opposite side of the barrier island offered visitors an alternative to the more physically demanding pursuit of sea bathing.

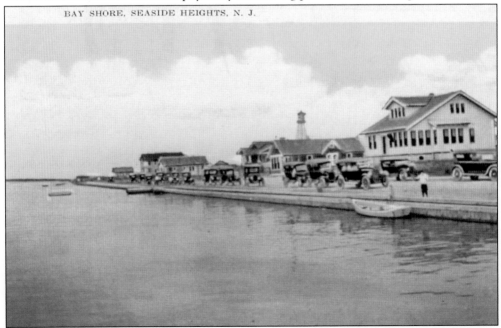

BAY SHORE, SEASIDE HEIGHTS, N. J.

Until the bulkhead was constructed, the first homes that were built along the bay front risked being flooded by nor'easters. The homes were so close to the bay that residents were able to moor their rowboats only 20 feet from their front yards. The two-story house with the scores of windows at the right side of this view card was located on the south corner of Webster Avenue.

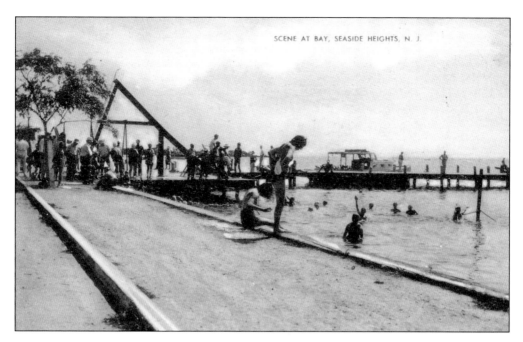

These cards show the swimming area adjacent to the Hotel Hamilton and Restaurant. Ropes limited the swimming zone about the dock, and in these views a lifeguard can be seen watching over the swimmers and divers. It was said that the noise from the swimmers at the bay beach dimmed the rumbling sounds of automobiles driving over the wood bridge. In the late 1950s, the New Jersey State Highway Department constructed a new Pelican Island bridge and cloverleaf interchange into Seaside Heights, Seaside Park, and Ortley Beach. The interchange was constructed on fill that was placed on the bay front roughly opposite Hamilton Avenue. These highway improvements would profoundly change the appearance of the bay shore area.

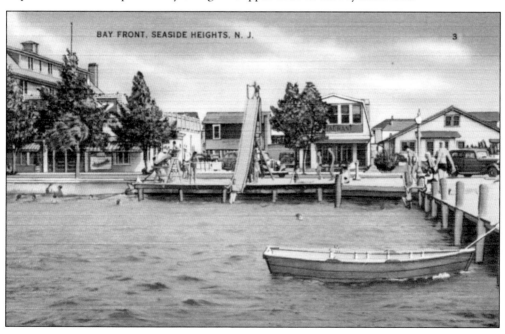

BAY FRONT, SEASIDE HEIGHTS, N. J. 3

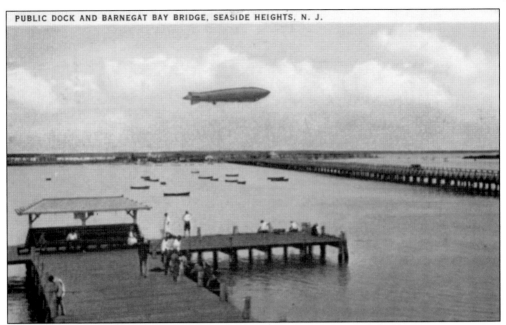

The focal point of this postcard, which was postmarked in 1936, is a blimp passing over the bay bridge. It was customary for the *Ocean County Review*, the local newspaper at the time, to report the arrival of the Graf Zeppelin and other prominent blimps flying to Lakehurst. One such report, published on August 9, 1929, stated that the Graf Zeppelin flew over Seaside Heights and dropped mail and souvenirs.

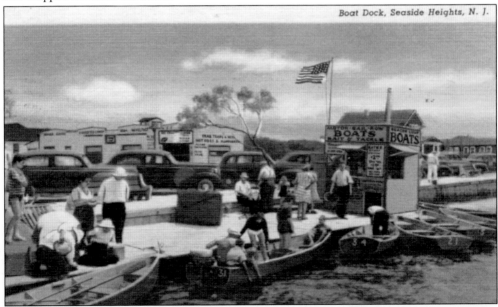

Boat Dock, Seaside Heights, N. J.

Early advertising brochures published by the Seaside Heights Board of Trade called attention to the bay's seemingly unlimited resources of sea bass, bluefish, weakfish, and crabs. As one brochure proclaimed, "Beautiful Barnegat Bay, which bounds Seaside Heights on the western side, is bulkheaded, and here will be found fleets of pleasure boats, with opportunities for fishing and crabbing which are unsurpassed."

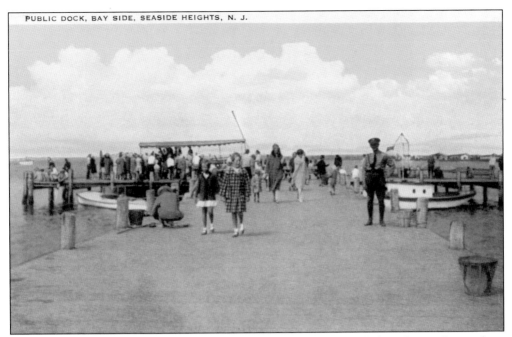

PUBLIC DOCK, BAY SIDE, SEASIDE HEIGHTS, N. J.

Among the crabbers and fishermen in this image is a group of people boarding a pleasure boat chartered for a day excursion on the Barnegat Bay. A Seaside Heights police officer is standing on the right side of the public dock, facing the camera.

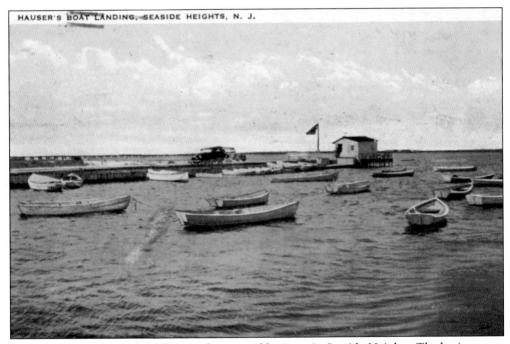

HAUSER'S BOAT LANDING, SEASIDE HEIGHTS, N. J.

George Hauser operated the first rowboat rental business in Seaside Heights. The business was located at the Grant Avenue Wharf. Hauser started with about a dozen rowboats but eventually grew his fleet to between 50 and 60 boats.

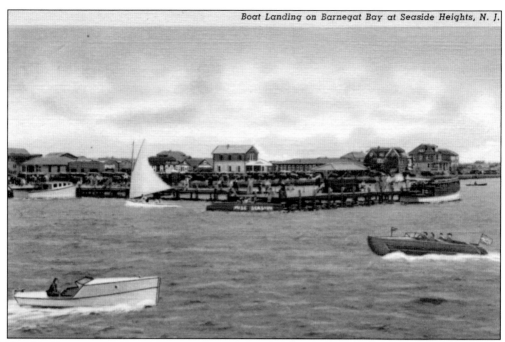

In this postcard, a boat named the *Miss Seaside* is moored to the public dock. Boating was a popular recreational activity for both the locals and visitors.

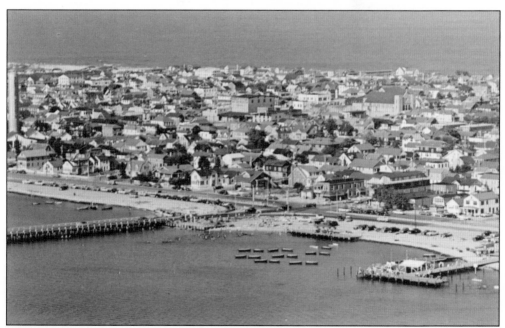

The presence of particular buildings in this aerial view helps date the photograph to between 1952 and 1956. When the New Jersey State Highway Department constructed a new interchange from Pelican Island into Seaside Heights in the late 1950s, most of the bay shore swimming areas and public dock that are visible in this view were filled in and paved over as part of the $3-million highway improvement project.

Five

AROUND THE TOWN

The Endres Building was located on the corner of Webster Avenue and the Boulevard. Benjamin Endres operated the pool hall and tobacco store on the north side of the building. In 1915, the Success Tonsorial Parlor, whose services included shaving, cutting hair, and trimming beards, took over a small section of the building. (Courtesy of Leonard Ipri.)

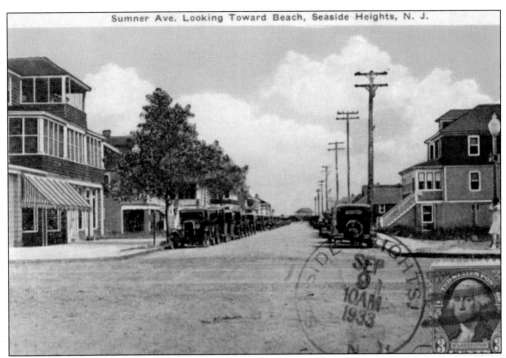

Sumner Ave. Looking Toward Beach, Seaside Heights, N. J.

Sumner Avenue and the Boulevard remains a prominent intersection in Seaside Heights. Over the years, these four corners have seen restaurants, boardinghouses, nightclubs, bakeries, retail stores, and the like come and go.

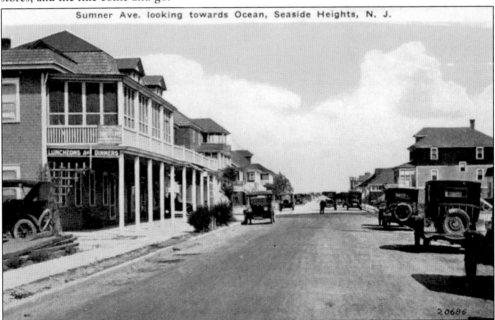

Sumner Ave. looking towards Ocean, Seaside Heights, N. J.

The building on the left, with the screened-in deck on the second floor, was the Sumner Hotel. According to this postcard, the building was located "One Square from the Railroad Station" and offered rooms for $2 per day. When the building was demolished on December 27, 1988, it was thought to be about 100 years old.

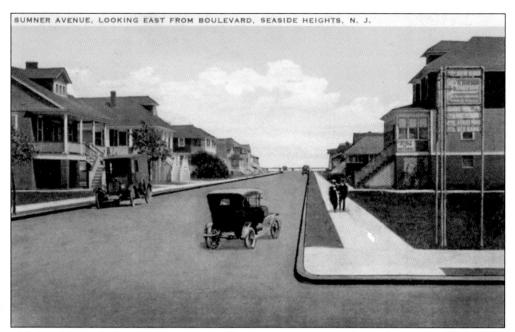

This is a scene of a man and woman strolling arm in arm on a tranquil Sumner Avenue. The sign on the southeast corner directs automobiles to turn right for Seaside Park and left for Point Pleasant, Asbury Park, and Red Bank.

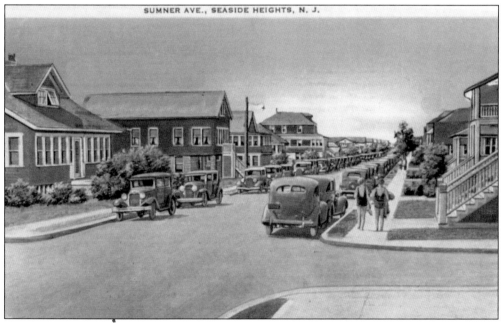

SUMNER AVE., SEASIDE HEIGHTS, N. J.

Clyde G. Marcy sent this card to a friend in Pennsylvania: "This view shows the street on which we live. Our home is the first cottage to the extreme left of picture. From the windows on the left edge of card, one can see out over the broad expanse of the Atlantic Ocean. Only one building between us and the beach. That is a store facing the boardwalk across Ocean Terrace from us."

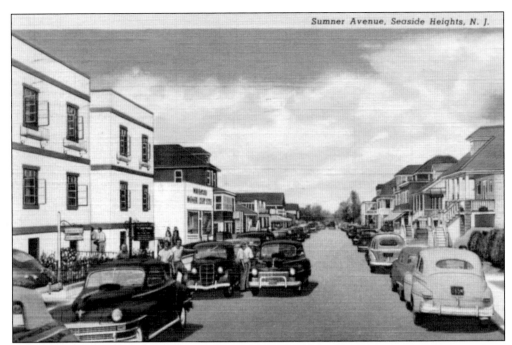

An automobile is stopped in the center of Sumner Avenue in front of the Ocean Manor Motel and Apartments. The motel's windows are opened wide, and all of the men in the scene are wearing short-sleeved shirts, indicating a hot summer day when this card was photographed in the early 1950s. To the right of the motel is the Wiener's Department Store warehouse.

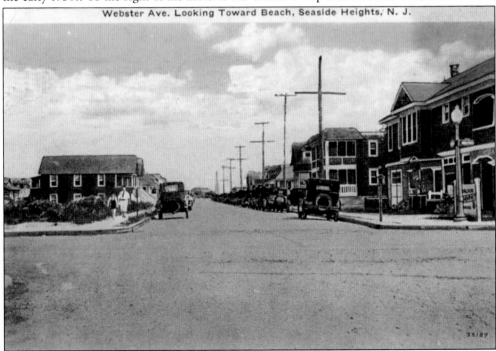

Webster Avenue and the Boulevard is another intersection that has gone through major changes over time. However, in this postcard the northeast corner was still just an empty lot.

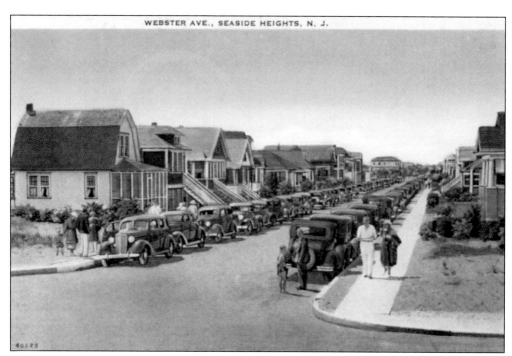

This view illustrates that parking has been at a premium in Seaside Heights for a very long time.

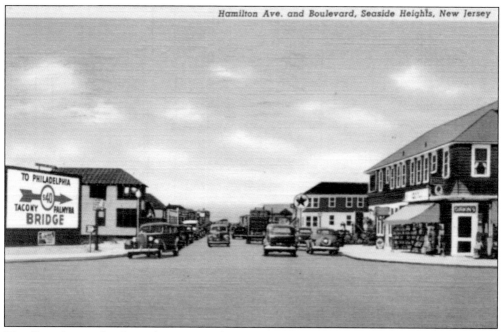

Hamilton Ave. and Boulevard, Seaside Heights, New Jersey

Hamilton Avenue has been the main road in and out of Seaside Heights for most of the town's history. Dirkin's Confectionary Store is shown here on the northwest corner adjacent to the Texaco service station.

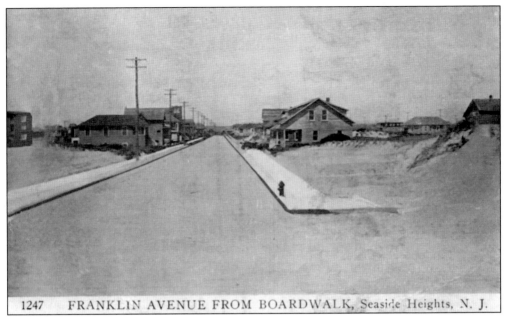

1247 FRANKLIN AVENUE FROM BOARDWALK, Seaside Heights, N. J.

This rare photograph shows Franklin Avenue when vacant lots were still available for purchase. Very early in the town's history, a 40-foot oceanfront lot could be purchased for $100. As development gained pace, however, a similar sized vacant lot sold for between $400 and $700.

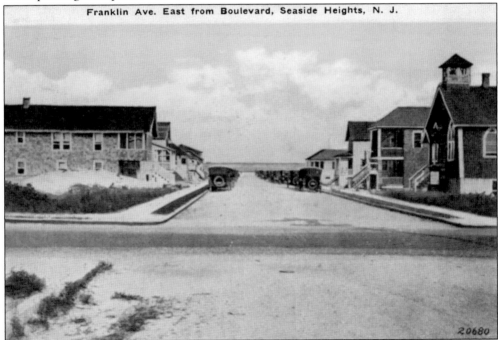

Franklin Ave. East from Boulevard, Seaside Heights, N. J.

Mailed on September 24, 1928, this card features a landmark that set apart this corner of town for many decades into the future—the Union Church. When this gable-roof structure was erected in 1921, the stained-glass windows on the east and west sides of the building contained symbols of maritime life. A bell was installed in the cupola the following year. The church abandoned the building in 1966.

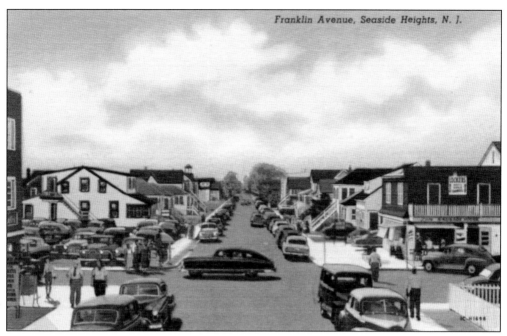

The corner of Franklin and Ocean Terrace Avenues is depicted in this scene. Leo's Sausage House is on the northwest corner. The bell tower of the Union Church can be seen above the rooftops on the south side of the street near the Boulevard.

In 1924, an ordinance was passed banning cars from streets after 11:00 p.m., because there were too many cars in town. A few enterprising individuals took advantage of the ordinance and opened garages and parking lots in town for automobile storage.

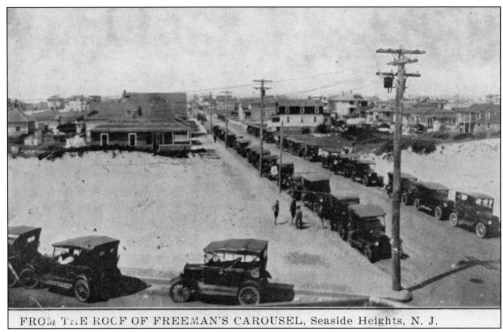

FROM THE ROOF OF FREEMAN'S CAROUSEL, Seaside Heights, N. J.

The large number of parked automobiles in this photograph suggests that Freeman's Carousel was full of activity on this particular day.

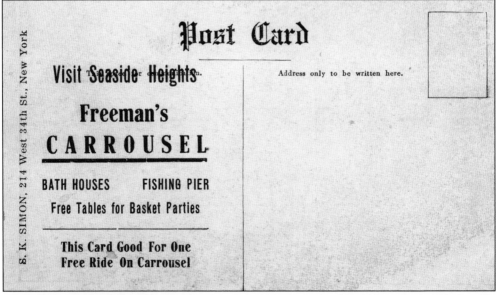

Misspellings were not uncommon in early postcards. This view shows the correspondence side of the above postcard. Notice that the card was "good for one free ride on carrousel" but the front of the card described the scene as a view from "Freeman's Carousel." One of the postcards on the next page used the incorrectly spelled word "carrousal" to describe the view.

DUPONT AVE. FROM BOARDWALK, Seaside Heights, N. J.

In 1911, the assessed valuation in Seaside Heights was $35,000. Four years later, the assessed valuation grew to $542,000. A real estate brochure that was published about 1916 identified a "Twin Cottage" for sale on Dupont Avenue between the Boulevard and Ocean Avenue. The seven-room furnished home, with large front and side porches, was listed for sale at $3,500 or as a rental for the entire summer at $160.

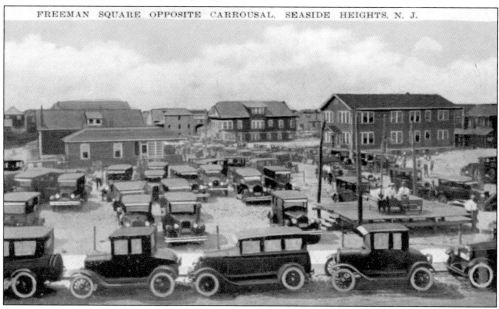

FREEMAN SQUARE OPPOSITE CARROUSAL. SEASIDE HEIGHTS, N. J.

The message on the back of this card, which was sent to Philadelphia in July 1934, covers three important needs of a visitor to Seaside Heights in that era: "Dear Anna, Having a nice time—fine weather. Lots of fish and crab and no mosquitoes." The writer was referring to the sunshine, locally caught seafood, and an apparent east wind that was keeping the mosquitoes away from the island.

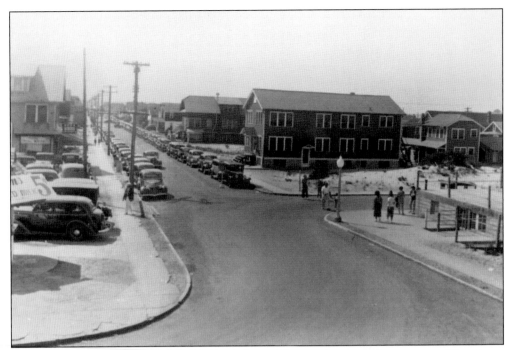

This view shows the corner of Dupont and Ocean Terrace Avenues after a new traffic pattern was established for the area. Looking west toward the Boulevard, it does not appear that even a single parking space was available on this particular afternoon. (Courtesy of Leonard Ipri.)

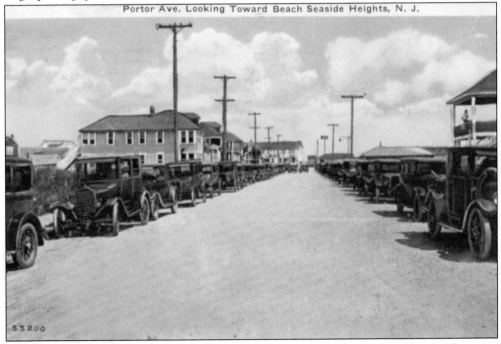

Porter Ave. Looking Toward Beach Seaside Heights, N. J.

Walking on the sidewalk opposite to the direction these automobiles are parked would end at Danceland on the boardwalk. This card contains another case of misspelled words. Locals know the street as Porter Avenue, not "Portor Avenue."

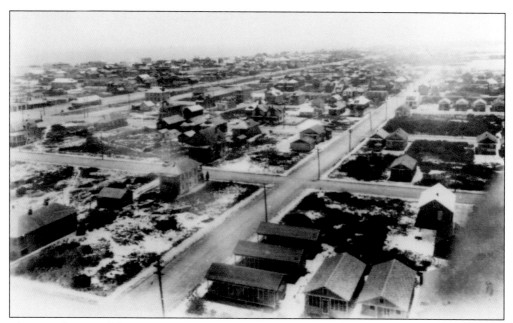

This aerial view of the town was taken looking southeast from the old water tower. The five cottages at the bottom right were located on the corner of Grant and Barnegat Avenues. The railroad station is visible on Central Avenue, right of Sumner Avenue, in the top left section of the view. The photograph was taken in the early 1920s. (Courtesy of Leonard Ipri.)

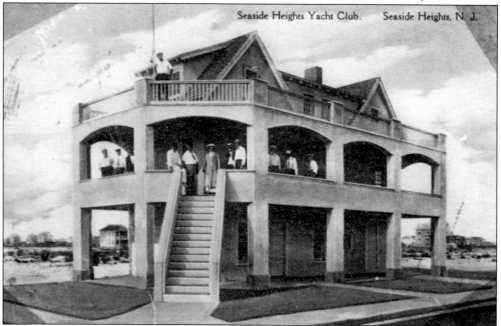

The location of the Yacht Club House at the bay front gave its members a commanding view of the entire Barnegat Bay. There was also a dance pavilion. An advertisement announced the grand opening of the club's nightly summer dancing. For an admission of 50¢, the public could dance on June 30, 1923, to the music of "The Famous Original Versatile Serenaders, direct from the El-Prinkipo Café, in Atlantic City, NJ."

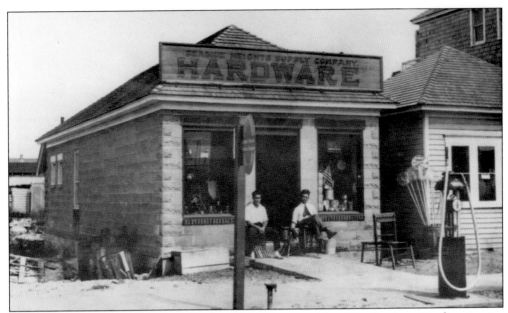

Seaside Heights Supply Company was located on the east side of the Boulevard in the vicinity of Sumner Avenue. In addition to hardware and other building provisions, the store sold fishing and crabbing equipment, automobile supplies, furniture, household utensils, and even American flags. One of the earliest manufactured gasoline pumps is set out in front of the store at the curb. (Courtesy of Leonard Ipri.)

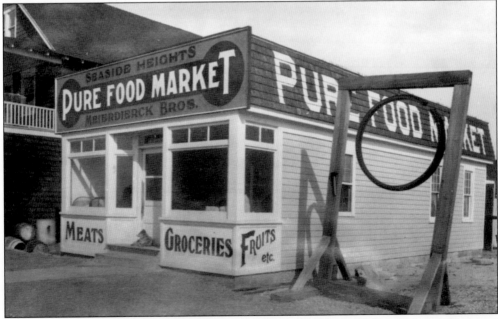

Christian Hiering, the cigar-smoking inventor who was affectionately called the "Father of Seaside Heights," was influential in the decision of many businesses to move into the area. One of those businesses was Meierdierck Brothers Food Market, which opened near the northeast corner of Sherman Avenue and the Boulevard in 1913. A fire bell sits next to the building in this photograph. (Courtesy of Leonard Ipri.)

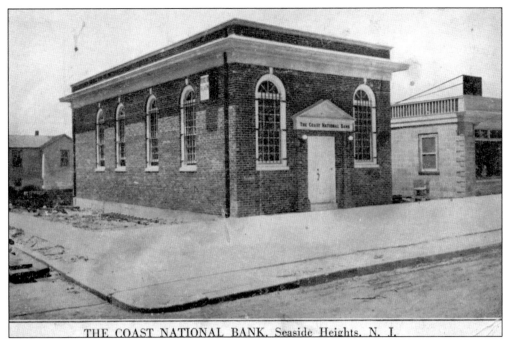

THE COAST NATIONAL BANK, Seaside Heights, N. J.

The Coast National Bank opened in 1923 on the corner of Webster Avenue and the Boulevard. The bank enticed new customers with its Christmas Club advertisement in the newspaper: "JOIN OUR CHRISTMAS CLUB; become a Systematic Saver and form the Banking Habit. Money in the Bank creates a wonderful feeling of happiness and independence." Coast National did not survive the bank panic of 1932 during the depths of the Great Depression.

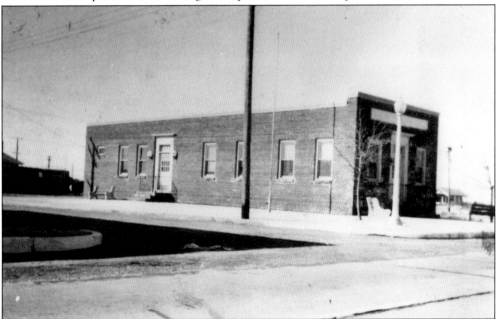

This photograph shows the Municipal Building on the corner of Sherman Avenue and the Boulevard before numerous renovations and additions would change its appearance in future years. (Courtesy of Leonard Ipri.)

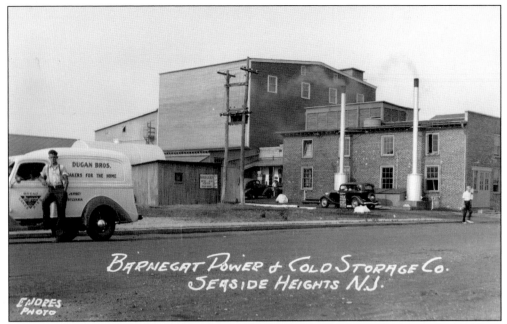

Ice making was the first local industry after the fish pounds. Noting that its plant manufactured "raw water ice," the company's advertising campaign warned the public to beware of "germ-laden ice taken from bays, rivers, lakes, and ponds whether used for the storage of fish or other uses."

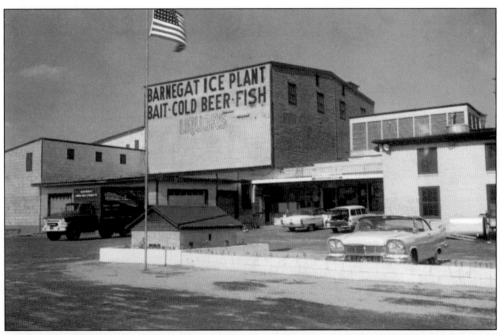

By the 1960s, the plant would be in the business of selling ice, cold beer, liquors, soda, bait, and all types of fancy frozen seafood. There was even a spigot so that the public could access well water at no charge. The large structure was demolished in 1978 after Chris and Julie Mesanko purchased the property in order to build their Rainbow Rapids water slide complex.

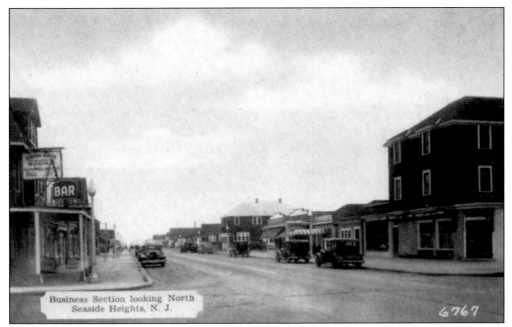

Business Section looking North
Seaside Heights, N. J.

6767

The advertising sign on the Sumner House (formerly the Sumner Hotel) invites the public to visit the store to read the daily and Sunday editions of the *Philadelphia Inquirer*. On the opposite corner is the Goodwin-Kramer Building, which housed offices of the town's first mayor, Edmund C. Kramer.

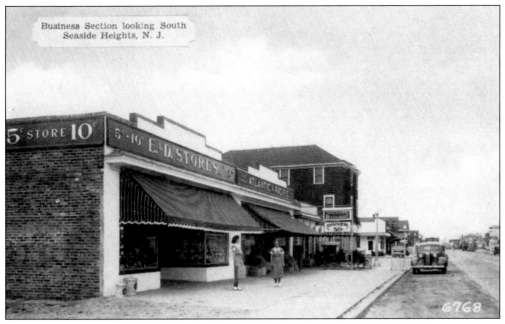

Business Section looking South
Seaside Heights, N. J.

6768

This view features E&D Stores, which published this postcard and the one above. This photograph was taken in the vicinity of Blaine Avenue and the Boulevard looking south. The Goodwin-Kramer Building is the tall structure past the Great Atlantic and Pacific store and restaurant. The Hoffman House is located on the southeast corner of Sumner Avenue.

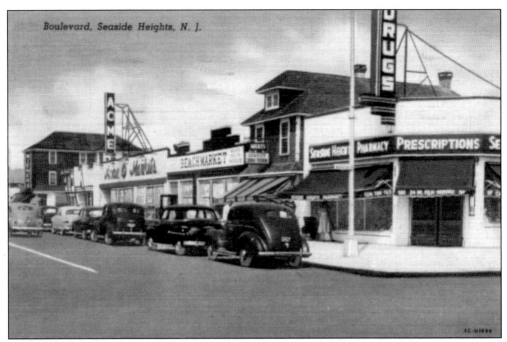

In this 1950s view, Sid Greenberg's pharmacy is on the northeast corner of Webster Avenue. A fund-raising brochure published in 1949-1950 by the fire company's Ladies' Auxiliary contained advertisements for numerous Boulevard businesses, including Monnie's Taxi, Ryan Real Estate, Leonard Ipri's Sweet Shoppe, Gang Plank Bar, Barney's Fish and Chips, Klee's Bar, Finn's 5¢ to $1 Store, Oliver R. Polhemus Contracting, Tex Gilmore's Gulf Service Station, and Max Baer's Ladies' Apparel Store.

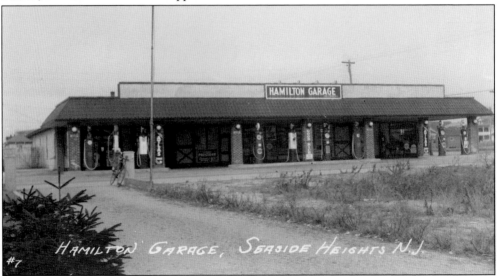

Located on the corner of Hamilton Avenue and West Central Avenue, the Hamilton Garage was owned by Bill Wittenberg. Wittenberg was active in local civic affairs and served on the borough council. The garage was purchased by Lou Casella in 1966. Casella was known by residents and customers to be a congenial person in and away from his business. He also was very active in the Seaside Heights Businessmen's Association.

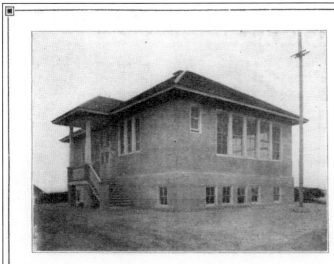

PUBLIC SCHOOL
Seaside Heights, N. J.

One of the most valuable assets in the growth and welfare of any community is its educational institutions, particularly its public schools. In this respect, Seaside Heights is fortunate in the possession of a new, sanitary school building, overlooking the Ocean, at almost the geographical centre of the Borough. The heating, lighting and ventilating systems are perfect. Modern plumbing, and spacious playrooms in the basement for use in inclement weather, all add to the comfort and convenience of the pupils.

Built by Clyde G. Marcy

Classes were taught in the basement of the Union Church until Clyde G. Marcy constructed the first public school at the ocean end of Sherman Avenue for just under $5,000. There were two school rooms, each designed to accommodate about 50 children. The basement housed playrooms and toilets. The board of education dedicated the schoolhouse with a flag-raising ceremony held on Washington's Birthday in 1915. (Courtesy of Leonard Ipri.)

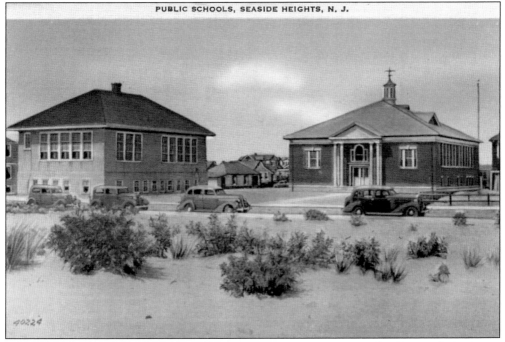

PUBLIC SCHOOLS, SEASIDE HEIGHTS, N. J.

The town continued to grow, and the need for a larger school was finally satisfied when a four-room, red-bricked schoolhouse was dedicated in the fall of 1927. The second school was built on the property next to the first school building. One of the first teachers in the second school was Paul K. Hershey, who also served as the school's principal.

53

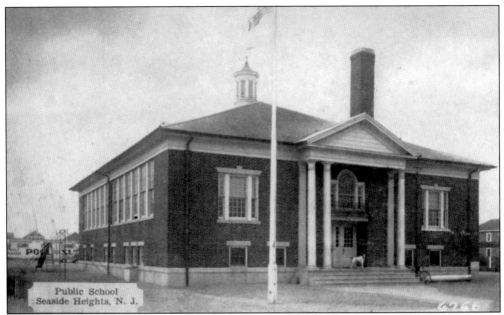

Public School
Seaside Heights, N. J.

This building would serve the town for 40 years, until overcrowding and the goal of maintaining a sound educational program demanded the construction of the present schoolhouse on the bay front in 1967. Paul K. Hershey served the school district as its principal from 1922 until he retired and was succeeded by Hugh J. Boyd Jr. in 1952.

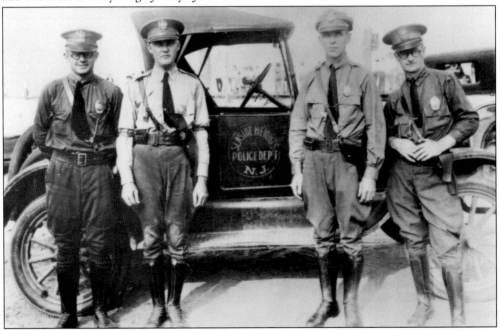

Law and order is maintained "in the town that fun built" by the Seaside Heights Police Department. Chief Frank B. Droughman was joined for this photograph in front of the department's police cruiser by Milton Endres, John Geeber, and William Kinnard. Joseph P. McDevitt became police chief in 1939, and he was followed by chiefs Edward Groffie, William Polhemus, Anthony Schremmer, Nate Horowitz, James Costello, and Thomas Boyd.

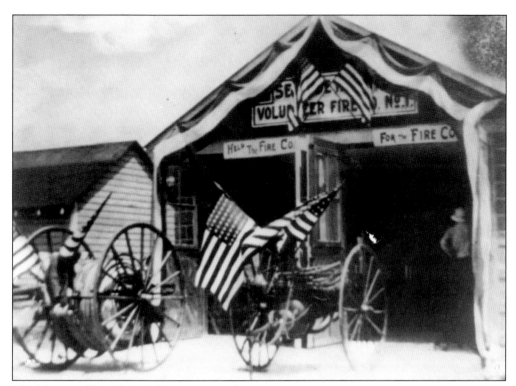

The history of Seaside Heights is entwined with the history of the Seaside Heights Volunteer Fire Company. In those beginning years, the fire company served a vital social purpose in the community. It maintained a baseball team for public games played against members of other fire companies, it sponsored dances, and many members were prominent citizens who served in government or owned local businesses. (Courtesy of the Seaside Heights Volunteer Fire Company Museum.)

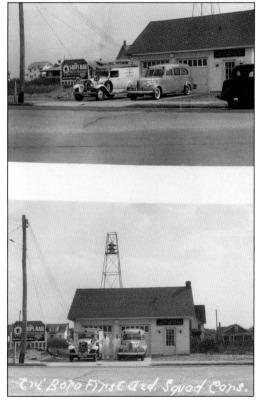

The Tri-Boro First Aid Squad's siren is perched on the tower behind its building. The organization was founded in 1938, with dedicated volunteers responding to emergency calls in Seaside Park, Seaside Heights, and Lavallette. After Lavallette organized its own first aid squad, Tri-Boro added Island Beach to its coverage area.

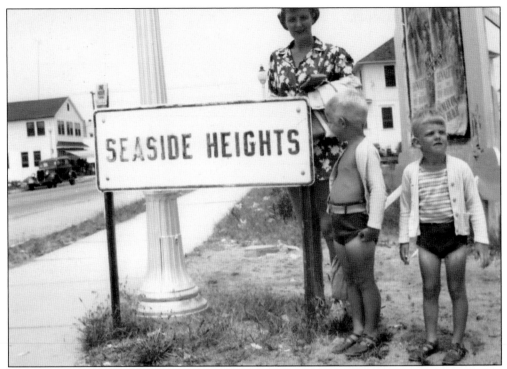

The movie billboard behind the woman and young boys provides an important clue as to when this Seaside Heights scene was likely photographed. In 1947, American stage and motion picture actress Joan Bennett portrayed Peggy, the deceitful wife in Jean Renoir's *The Woman on the Beach,* opposite Robert Ryan and Charles Bickford. The movie was shown at the Strand Theatre in July that year.

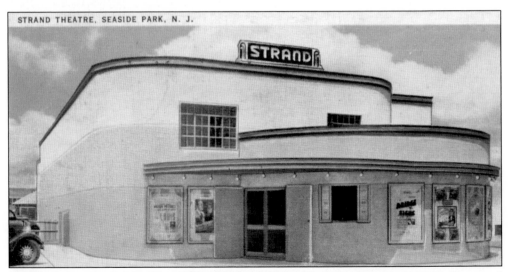

The poster on the front of the building is advertising the Onslow Stevens, Dorothy Tree, and Jack La Rue movie *The Bridge of Sighs.* The Strand Theatre opened in 1934 and was located on the corner of Porter and Ocean Avenues, technically in Seaside Park. Families from all over the barrier island paid to see the latest motion pictures at the Strand until the theater closed in 1972.

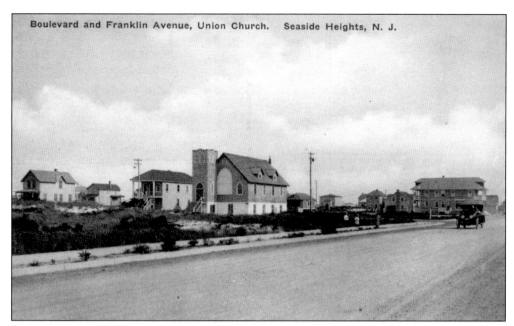

Boulevard and Franklin Avenue, Union Church. Seaside Heights, N. J.

This card shows the Union Church at the corner of Franklin Avenue and the Boulevard before it crumpled like a cardboard box in a storm in June 1920. Down but not out, members of the church made immediate plans to raise funds and rebuild. In the meantime, church services were temporarily held at the Seaside Heights Yacht Club.

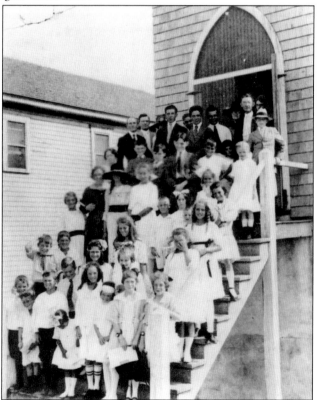

In this photograph, children pose with their Sunday school teachers on the steps of the Union Church. In the fall of 1913, the Manhassett Realty Company donated two lots on Franklin Avenue to be used for a church. Construction began the following spring. Inspiration was so extraordinary that every carpenter in Seaside Heights volunteered a free day's work. The building was dedicated in August 1914. (Courtesy of Leonard Ipri.)

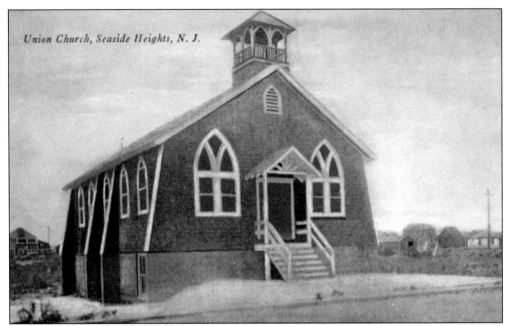

Union Church, Seaside Heights, N. J.

A new building for Union Church, erected on the original site at 57 Franklin Avenue, was completed early in the summer of 1921. This building would house the church until 1966, when it was replaced by a semi-Colonial style, 325-seat structure on the corner of Hiering and Central Avenues.

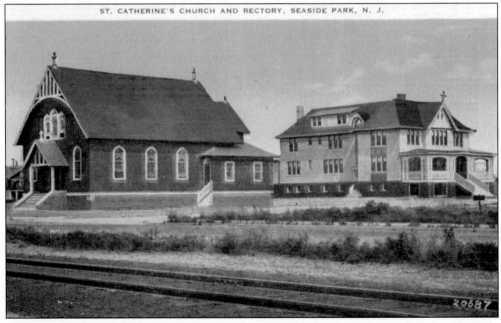

ST. CATHERINE'S CHURCH AND RECTORY, SEASIDE PARK, N. J.

Although St. Catharine of Siena Church was located many blocks to the south in Seaside Park, families living in Seaside Heights who desired a Catholic service were not dispirited by having to walk along the railroad tracks on Central Avenue to the church. No doubt the jovial priests of the Franciscan order who held Mass at St. Catharine's gave them an entertaining and moving sermon to look forward to.

The Seaside Bible Church was organized in May 1942. The church building was the former home of Christian Hiering and his family. The message on the postcard paid a compliment to Pastor Eugene Potoka's morning worship sermon and expressed the writer's plan to return to the church later for Evening Fellowship Hour.

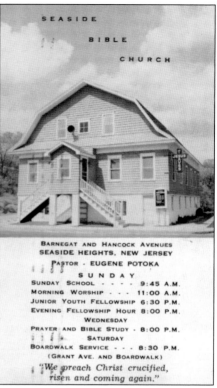

SEASIDE

BIBLE

CHURCH

BARNEGAT AND HANCOCK AVENUES
SEASIDE HEIGHTS, NEW JERSEY
PASTOR · EUGENE POTOKA
S U N D A Y
SUNDAY SCHOOL · · · · 9:45 A.M.
MORNING WORSHIP · · · 11:00 A.M.
JUNIOR YOUTH FELLOWSHIP 6:30 P.M.
EVENING FELLOWSHIP HOUR 8:00 P.M.
WEDNESDAY
PRAYER AND BIBLE STUDY · 8:00 P.M.
SATURDAY
BOARDWALK SERVICE · · · 8:30 P.M.
(GRANT AVE. AND BOARDWALK)
*"We preach Christ crucified,
risen and coming again."*

Catholic Church, Seaside Heights, N. J.

Our Lady of Perpetual Help Church was founded in 1942. Services were held in the parish chapel located on Lincoln Avenue and the Boulevard until it was destroyed by fire in September 1949. The Reverend Thomas Barry temporarily held Mass for overflowing crowds at the Casino Skating Rink as well as the large, Quonset-type building that was erected by the Catholic Youth Organization. The new tan brick church was dedicated on July 6, 1952.

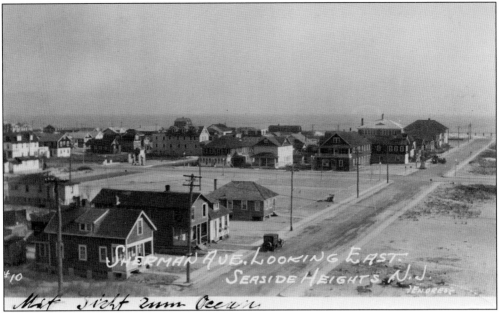

This aerial view of Sherman Avenue, looking toward the ocean, is postmarked 1937. The Sheridan Hotel can be seen on the corner of Sheridan Avenue and the Boulevard, opposite the gasoline station on the northeast corner. The St. Charles Hotel, with its distinctive box-bay windows on the third floor, rises above the other structures on Sheridan Avenue.

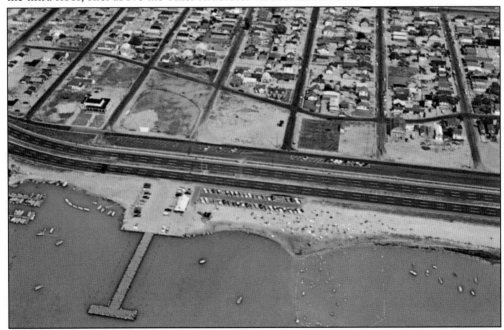

This view shows the bay front between Sheridan Avenue and Hiering Avenue after the state highway was constructed in the late 1950s. The Seaside Bible Church and American Legion building are prominent landmarks. The modern, seven-classroom school now known as the Hugh J. Boyd Jr. Elementary School would be dedicated in 1968 and today fills the large empty lot that is immediately south of the baseball field in the postcard.

Six

SEASIDE HEIGHTS RAILROAD STATION

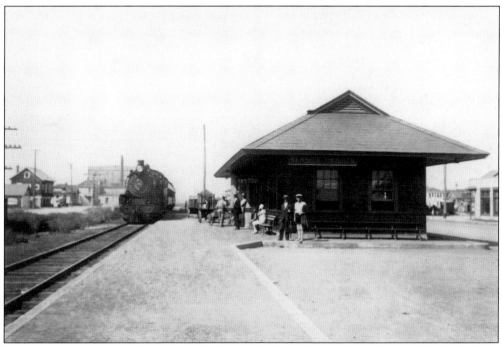

A locomotive is seen here arriving at the passenger terminal. Between 1880 and 1883, the Pennsylvania Railroad extended its Camden-Pemberton branch through the pine barrens to Toms River, crossing the upper Barnegat Bay on a trestle to Seaside Park. From there, the line pushed north through the Island Beach peninsula and on to Bay Head, where it connected with the New York and Long Branch Railroad. (Courtesy of Leonard Ipri.)

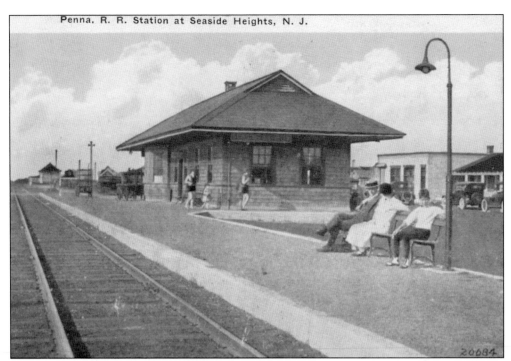

The passenger terminal, built on Central Avenue between Webster and Sumner Avenues, replaced a more modest train stop that previously served Seaside Heights. In 1915, the ice plant had a siding constructed from the main railroad track in order to bring in coal and take out ice. The sender of this card wrote, "What do you think of the R.R. station? Some bathing beauties at the station I noticed. Ha! Ha!"

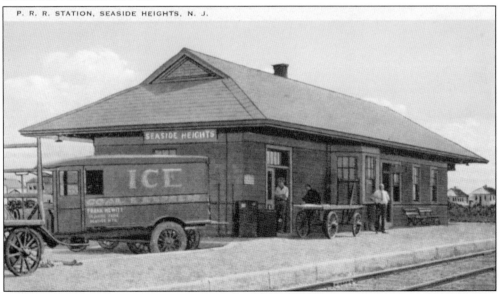

P. R. R. STATION, SEASIDE HEIGHTS, N. J.

A delivery truck belonging to Frank Hewitt of Seaside Park is parked next to the passenger terminal in this postcard. Hewitt guaranteed early morning deliveries of ice and coal and offered general express services. Numerous other delivery companies also met the trains to haul trunks and baggage.

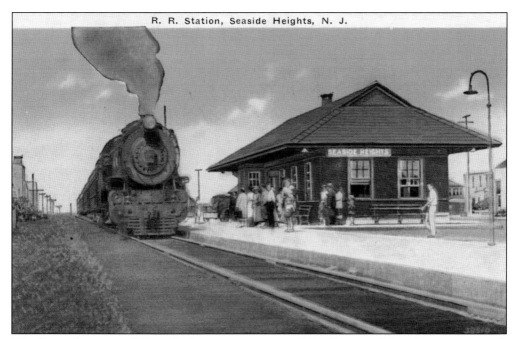

The first trains to travel through the area were not models of luxury. Often there was so much smoke from the engine that coach windows had to be kept closed. In spite of this, passengers arrived at the seashore "with soot in their hair and grime in their ears." Seats in those trains were plain boards without cushions.

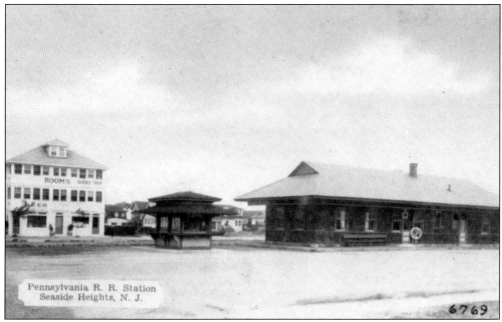

Pennsylvania R. R. Station
Seaside Heights, N. J.

6769

Featured in this real-photo postcard are the passenger terminal and the northwest corner of Webster Avenue. Homes on Sumner Avenue can be seen between the kiosk and terminal. A vendor sold newspapers, magazines, and candy to travelers and locals from the kiosk.

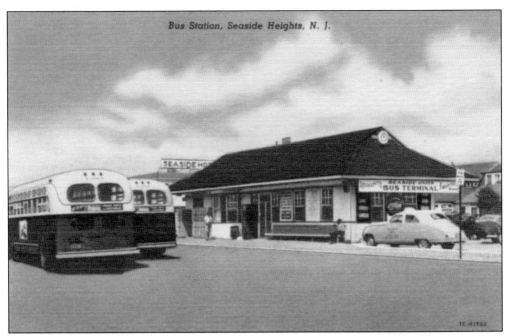

Bus Station, Seaside Heights, N. J.

The railroad bridge linking the mainland with the barrier island was claimed by a fire in December 1946. At a public meeting held to determine the future of the railroad, Mayor J. Stanley Tunney proclaimed that the railroad was a "menace" because the rail divided the town in half, causing delays in crossing the track, and made it virtually impossible for the fire company to respond to fires on the west side of the tracks.

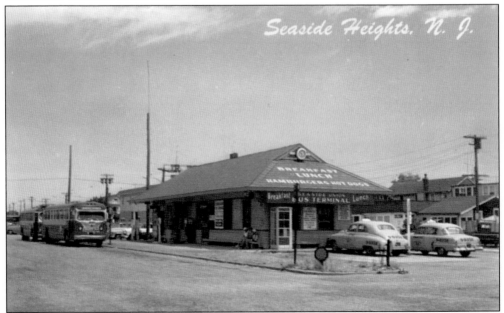

Seaside Heights, N. J.

The passenger terminal is shown in this postcard and the one above after it was converted to a bus station after the Pennsylvania Railroad was given permission in 1948 to abandon its right-of-way. In later years, bus service was moved to a different location in the town and the building was used as a restaurant and hospital medical annex before being torn down.

Seven

PLACES TO
EAT, DRINK, AND SLEEP

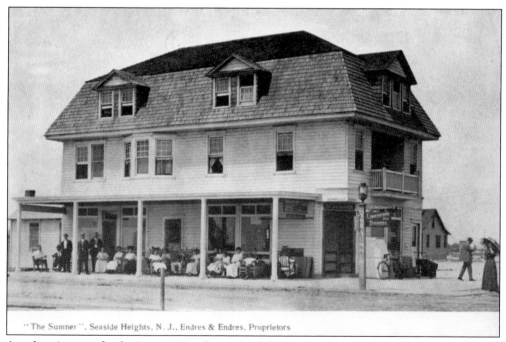

"The Sumner", Seaside Heights, N. J., Endres & Endres, Proprietors

An advertisement for the Sumner Hotel contained this verse written by Anna R. Towers: "Come married men, bachelors, widowers, all . . . Come to the Sumner both great and small. Warm rooms in daytime, blankets at night . . . hot cakes for breakfast—to our heart's delight. Today, we've roast beef, fish, chicken, vegetables, desserts for dinner. A meal to please either saint or sinner. Then why go elsewhere? You really might freeze. Better come to the Sumner where you don't even sneeze."

"The Milton"

Corner of

East Central & Porter Aves.

Nine large rooms and store.
For rent, $15.00 a week, furnished. Season $200.
For sale. Entire corner property including small bungalow in rear shown in illustration for $3000.

P. A. Carney,

204 Dawson St.,

Wissahickon, Phila., Pa.

OR

Clyde G. Marcy,

Seaside Heights, New Jersey.

Built by Clyde G. Marcy

The three-story Milton on Porter Avenue was a nine-room hotel and store. (Courtesy of Leonard Ipri.)

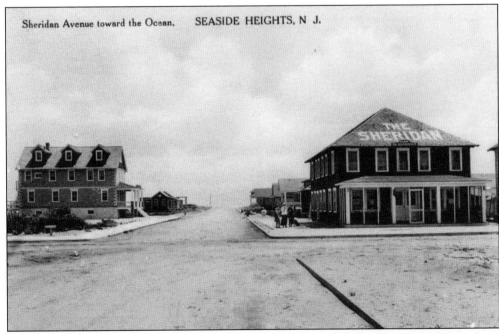

Sheridan Avenue toward the Ocean, SEASIDE HEIGHTS, N. J.

The Sheridan Hotel, corner of Sheridan Avenue and the Boulevard, offered steam heat, large rooms, hot and cold water baths, and a private dining room. The Sheridan was one of the first hotels in Seaside Heights and is considered to be the first establishment that sold ice cream. In a different era, the building would become the home of Good Time Charlies and Charlies Attic Speakeasy.

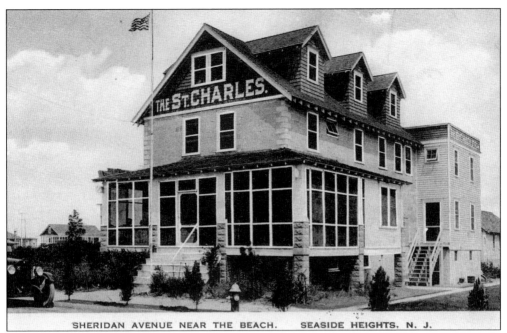

SHERIDAN AVENUE NEAR THE BEACH. SEASIDE HEIGHTS, N. J.

This card was postmarked in 1923 and shows another of the town's first hotels. The St. Charles was built in 1914 by Mrs. M. C. Koch, who operated the hotel for more than 30 years. The hotel could accommodate 40 to 50 people. The rooms on the third floor provided an unrestricted view of the ocean and bay.

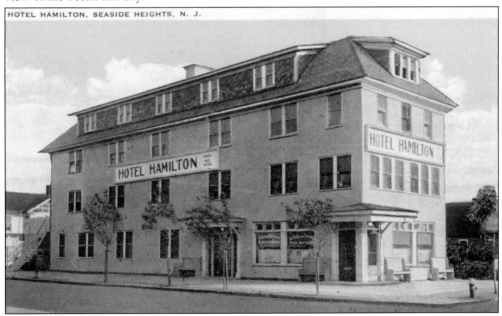

HOTEL HAMILTON, SEASIDE HEIGHTS, N. J.

Unlike most of the other hotels and restaurants in Seaside Heights that concentrated their business east of Central Avenue, the Hotel Hamilton served people who preferred the activities on the bay front. The four-story climb was no doubt a challenge for even the most physically fit vacationer. There were 54 rooms with baths, and in 1930 the owner installed an indoor 18-hole golf course.

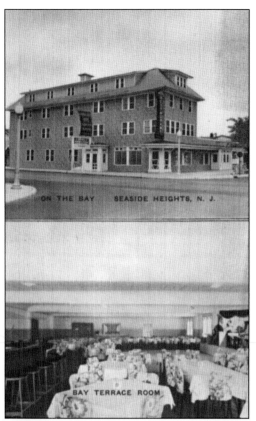

The Bay Terrace Room, a cocktail bar and club, is featured in this "Hotel Hamilton on the Bay" lobby card. In the bottom portion of this card, the bar can be seen on the left. A dance floor and band stage promised nightly dancing and entertainment during the summer. An advertisement in May 1946 offered a full-course dinner of steaks or chops for only $1.25.

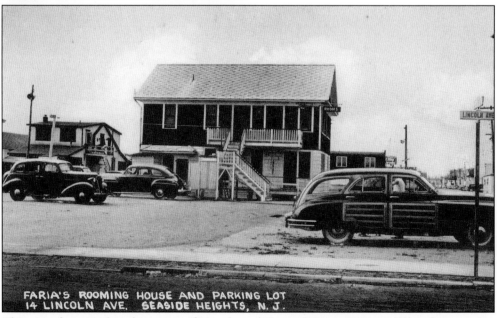

This view faces north at the corner of Lincoln and Ocean Terrace Avenues. What this rooming house may have lacked in aesthetic appeal was more than made up for by its close proximity to the boardwalk and amusements.

Tel. Seaside Park 9-0258 One Block From Ocean

HERSHEY COTTAGES
MOTEL and CABINS

Private Baths ... Hot Showers ... Innerspring Mattresses ... Electric Refrigerators ... Gas Stoves ... Hot Water ... Bathing at Beach and Bay ... Restaurant

Boulevard at Sampson and Carteret Avenues

SEASIDE HEIGHTS, N. J.

According to this lobby card, Hershey Cabins offered the most modern conveniences that were available at that time.

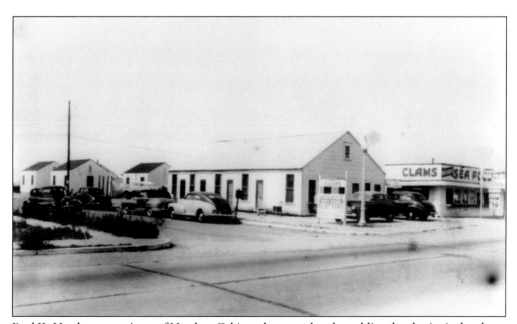

Paul K. Hershey, proprietor of Hershey Cabins, also served as the public school principal and was an active member of the volunteer fire company. His son P. Ken Hershey assumed the management of the establishment and operated the contemporary motel and restaurant that today stands at the northwest corner of Carteret Avenue and the Boulevard. (Courtesy of Leonard Ipri.)

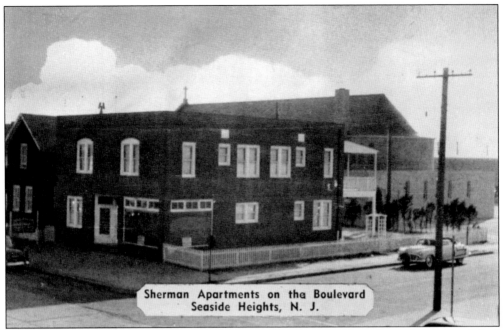

Sherman Apartments on the Boulevard
Seaside Heights, N. J.

Sherman Apartments was located across the street from the Seaside Heights Municipal Building and adjacent to the rear of Our Lady of Perpetual Help Catholic Church. Two-room apartments were available in this complex, which was located only one block from the beach, pool, and boardwalk.

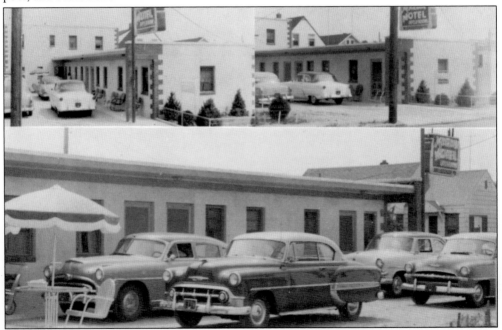

The Marian Motel was open from May to September. It offered the convenience of being located only one block from the beach on Kearney Avenue. When a place like the Marian Motel advertised off-street parking, it often meant that the keys would have to be left with the manager so he could jockey automobiles in and out of the parking area and driveway.

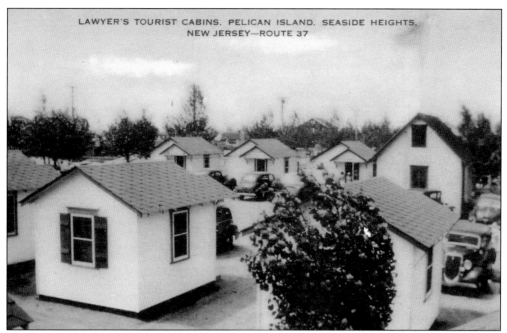

These individual cabins provided more privacy than many of the rooming houses and apartments in Seaside Heights. They could be rented from Lawyer's Tourist Cabins located on the north side of Pelican Island. Lawyer's also rented rowboats. A 1952 advertisement stated a price for rowboat rentals of $1.25 per day, $8 per week, and $21.50 per month.

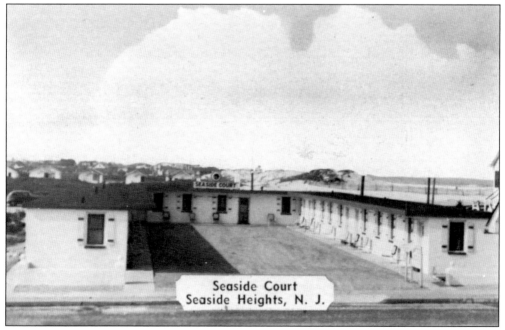

On the oceanfront, the Seaside Court Motel offered two-room efficiency apartments with a gas range and refrigerator in each unit. The high dunes that existed for many years on the beach in the vicinity of Hiering Avenue are visible in the center right section of the postcard.

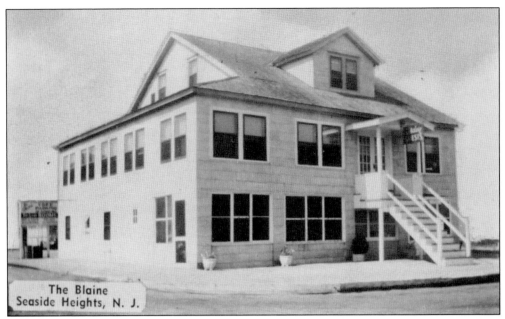

The Blaine
Seaside Heights, N. J.

Rooms at the Blaine were available by the week or month and came with hot showers, bathing privileges, and a porch for recreation. This large rooming house was located on the corner of Blaine and Ocean Terrace Avenues until it was demolished by a future owner. Townhomes occupy the site today, making this corner virtually unrecognizable from the earlier era depicted in this postcard.

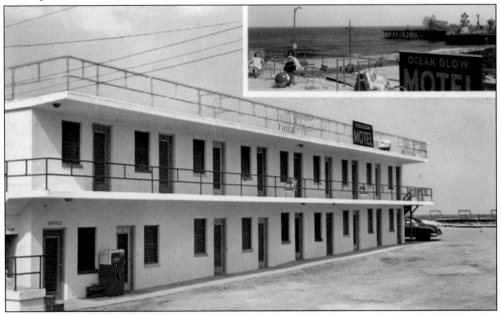

The Ocean Glow Motel, with doors and railings painted bright red, blue, green, yellow, and orange, presented vacationers the best of both worlds. The motel was located so close to the ocean that people could "see it, hear it, smell it, taste it, and feel it." Yet the boardwalk north of the Casino Pier was undeveloped, and guests could sit on the rooftop deck and peacefully take in the views and breezes.

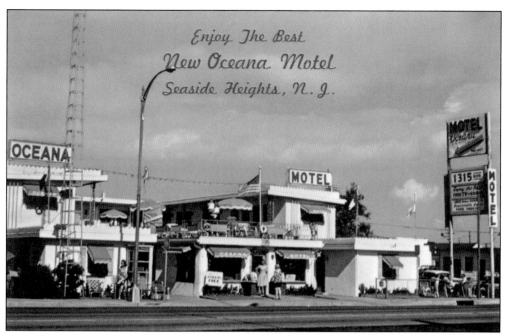

Guests of the Oceana Motel were surrounded by a nautically themed facade and could sit on the sun deck and socialize with one another well into the early morning hours.

Even though the Golden Nugget Motel advertised that it was "Located in the Heart of all Attractions," with the ocean and the Casino pool only a short distance away, the motel had its own swimming pool. In this view, the St. Charles Motel can be seen on Sheridan Avenue behind the Golden Nugget. The Golden Nugget Motel still rents its rooms along the Boulevard.

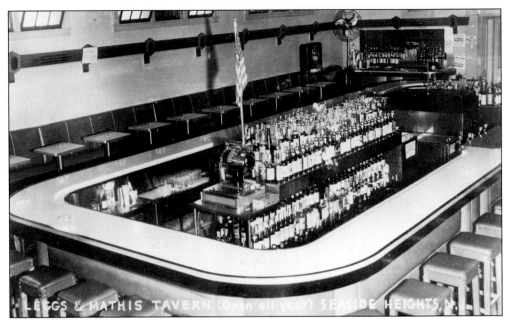

Tommy Leggs and Podge Mathis were the proprietors of Leggs and Mathis Tavern. The establishment was purchased in December 1951 and became Jerry Redmond's Fine Tavern and Hotel. Musical entertainment was provided by Jack Rhodes at the Hammond organ. Patrons were called upon to name their favorite tune, and Rhodes would skillfully play it on the Hammond.

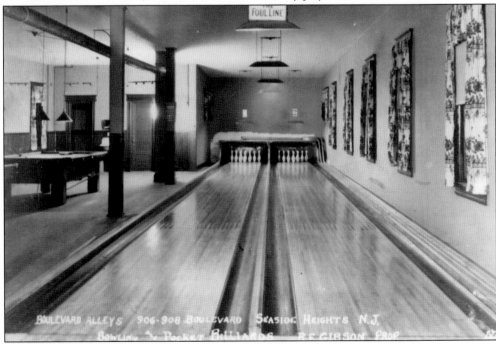

R. E. Gibson's Boulevard Alleys was located in Holland Hall on Sherman Avenue and the Boulevard. In later years, approximately 1948, a second bowling alley opened, Sisk's Bowling Center, located on Dupont Avenue with Brunswick semiautomatic pin setters. (Courtesy of Leonard Ipri.)

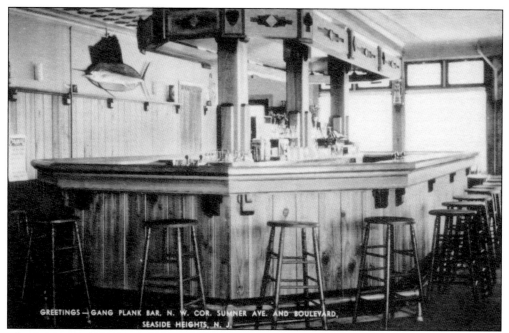

The Gang Plank Bar, "Where Good Fellows Meet," conducted its business on the corner of Sumner Avenue and the Boulevard.

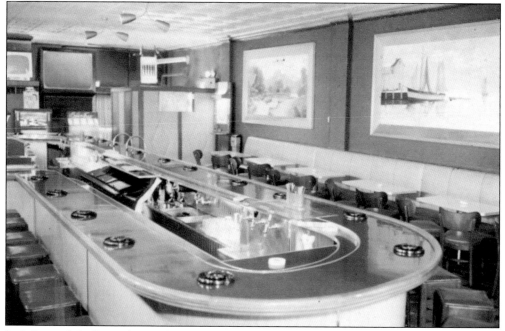

Joe's Bar and Grill, on the Boulevard, added shuffleboard and a large-screen television to entice customers to the establishment. This photograph was taken around 1950.

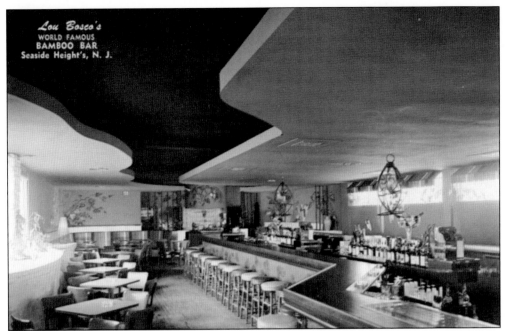

Pictured is the interior of Lou Bosco's World Famous Bamboo Bar that was located on the boardwalk east of the Casino building. In 1945, a new nautical bar overlooking the ocean was launched on the open-air deck. The Bamboo Bar, a favorite of locals and vacationers alike, featured dancing and live entertainment.

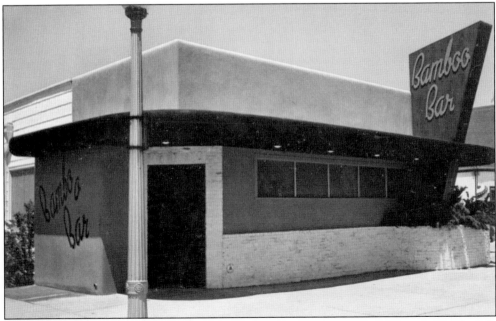

The Bamboo Bar moved from the boardwalk to its present location on the corner of Lincoln Avenue and the Boulevard. This is a 1960s–1970s view of the establishment. The Bamboo Bar has undergone major renovations and expansion over the past 20 years and today occupies the entire west Boulevard frontage between Lincoln and Franklin Avenues.

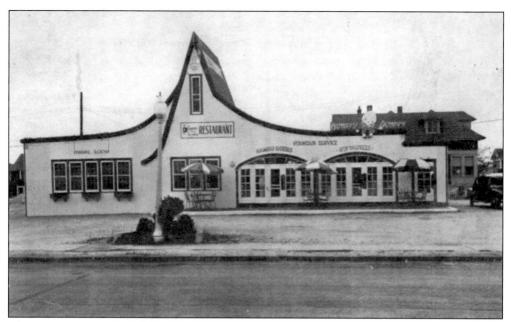

The Humpty-Dumpty Restaurant was inviting because of its novel and appealing architectural design and attractively decorated interior with seating for up to 100 people. This establishment stood on the Boulevard at Franklin Avenue for many decades.

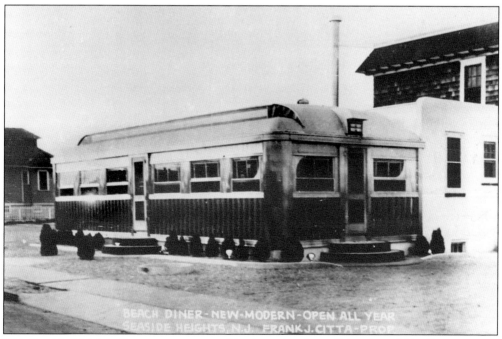

This Seaside Heights diner was constructed in the style of a traditional roadside diner.

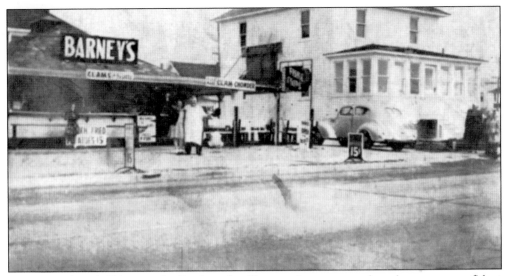

Barney's Fish and Chips, on the Boulevard at Dupont Avenue, must have been very confident that its clam chowder and "famous fish and chips" would help its female diners forgive the advertisement that was included in a 1950 business directory: "If Your Wife Can't Cook, Keep Her for a Pet and Eat Here."

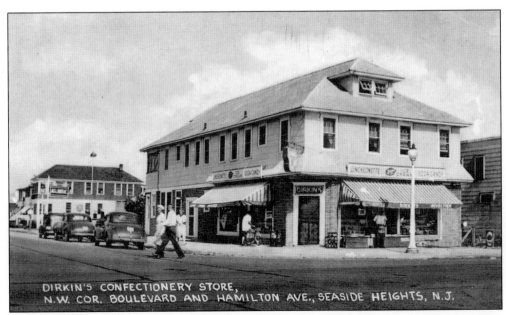

The second floor of this corner building served as Dr. W. J. Dirkin's dentistry office.

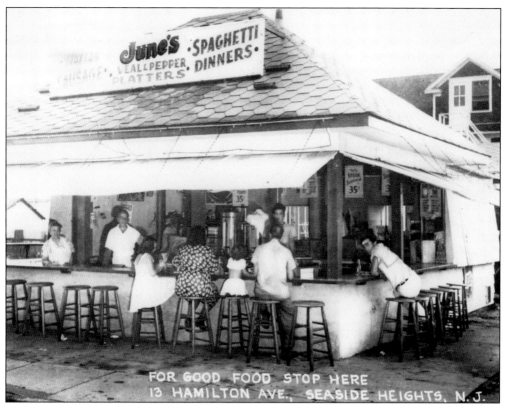

Diners sit on stools in front of June's food stand on Hamilton Avenue near Ocean Terrace Avenue. This establishment and the one in the view below it on Franklin Avenue are good examples of the types of eateries that sprang up in Seaside Heights as the town's reputation as a summer resort spread. But despite the opportunities that were available after World War II, it was not uncommon for ownership of summer businesses to change hands regularly. Many unseasoned entrepreneurs learned the hard way that the promise of financial reward can be realized only through hard work and very long hours—and dependably good weather.

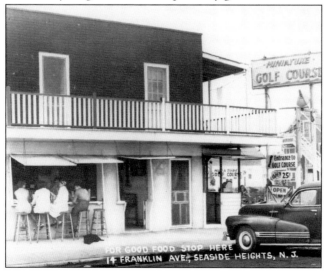

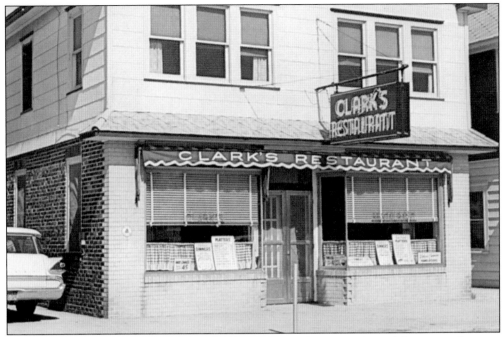

Clark's Restaurant was located on the west side of the Boulevard between Dupont and Lincoln Avenues.

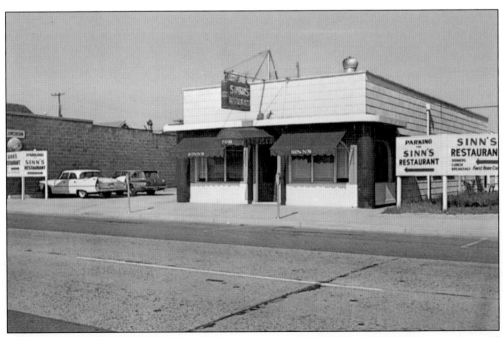

Sinn's Restaurant was established in 1944 and was a mainstay of Seaside Heights eateries until the establishment burned down after more than four decades of serving residents and visitors.

Eight

FREEMAN'S AMUSEMENT CENTER

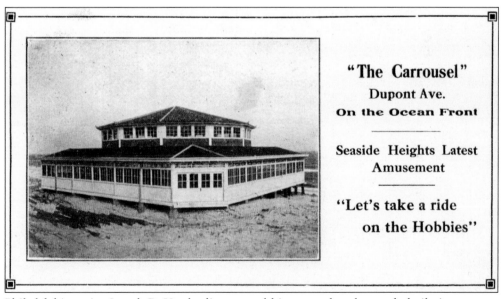

"The Carrousel"
Dupont Ave.
On the Ocean Front

Seaside Heights Latest Amusement

"Let's take a ride on the Hobbies"

Philadelphia native Joseph B. Vanderslice opened his carousel at the newly built Amusement Palace on August 27, 1915. The steam-driven merry-go-round with an imported German organ, as well as drums and cymbals, was erected inside this unassuming round pavilion that was located less than a few hundred feet from the ocean. Vanderslice and his Senate Amusement Company also erected the first section of boardwalk. (Courtesy of Leonard Ipri.)

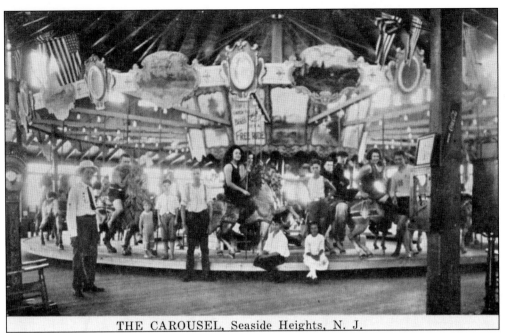

THE CAROUSEL, Seaside Heights, N. J.

Vanderslice had remarkable vision and enterprise to believe that his machine and its mechanical orchestra could inspire a major amusement center that would define Seaside Heights in future years. In this card, which was postmarked in the summer of 1923, riders pose on the carousel in between rides. A sign behind the riders offers a free ride on the hobbies to anybody who can catch the brass ring.

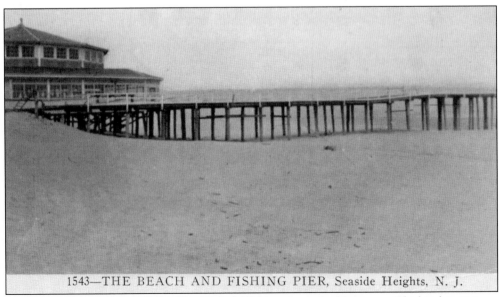

1543—THE BEACH AND FISHING PIER, Seaside Heights, N. J.

Unfortunately, Vanderslice did not live to see his labor crowned with success. The local newspaper reported Vanderslice's death in Philadelphia in March 1916, proclaiming that he died of a broken heart from the financial pressures brought upon him by schemers who falsely professed to be his trusted friends. In this view, taken from the south, the new fishing pier is featured. The pier was opened in July 1921.

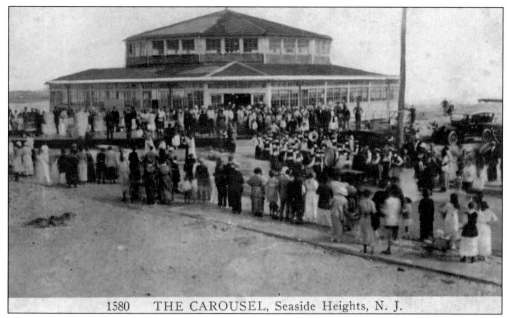

1580 THE CAROUSEL, Seaside Heights, N. J.

The carousel was the site of this "Baby Show and Parade." Early baby parades were typically sponsored by one of the local social clubs, such as the Ladies Auxiliary of the Seaside Heights Yacht Club or the Ladies' Aid of the Union Church. The carousel pavilion was also the center of many fund-raisers, including a watermelon party and two-day bazaar in August 1920 to raise funds to rebuild the Union Church.

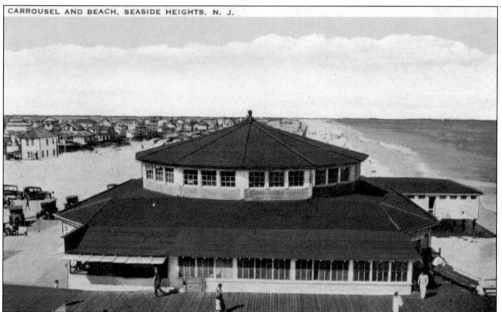

CARROUSEL AND BEACH, SEASIDE HEIGHTS, N. J.

After her husband's death, Mrs. J. B. Vanderslice was unsuccessful in keeping the carousel open. The entire oceanfront estate, with the valuable riparian rights, was acquired in 1917 by J. Milton Slim and Frank H. Freeman. One of the first improvements made by the businessmen was to replace the steam-driven carousel with an electrically powered machine built in the Philadelphia style by Gustav A. Dentzel and one of his master wood-carvers, Daniel Muller.

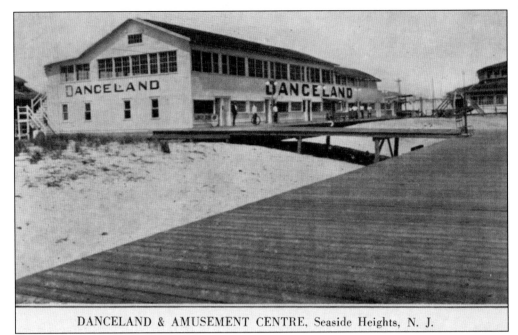

DANCELAND & AMUSEMENT CENTRE, Seaside Heights, N. J.

F. H. Freeman and a business partner, Anton Steidle, built Danceland and 15 stores on the vacant land between the carousel and Porter Avenue. The dance hall was located on the second floor and ran the full length of the first-floor stores. Danceland was designed for comfort, providing a double floor made of seasoned maple, refreshment and reception rooms, toilets, and wardrobes and parlors.

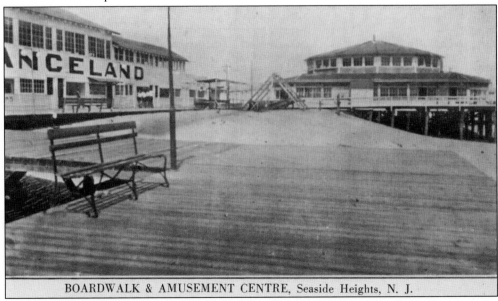

BOARDWALK & AMUSEMENT CENTRE, Seaside Heights, N. J.

When Danceland opened on June 14, 1922, under the management of well-known musician and dance master Otto Geiler, there was an orchestra of seven jazz pieces. Customers paid 25¢ for admission. Steidle and Freeman promised that only strictly approved dances would be permitted, and, to make the point, they invited parents to be present to see for themselves just how Danceland would be conducted.

84

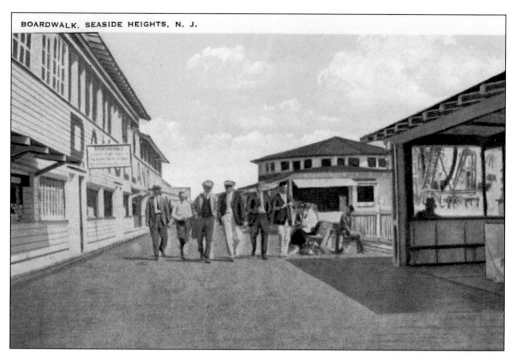

A finely dressed group of strollers walk by the stores located on the ground floor of Danceland. Soon after the first tenants opened for business, however, the building's owners had their first challenge. In July 1922, Mayor Frederick Jones, who had campaigned on a platform to prevent dancing and movies on Sundays, decided to close the boardwalk stores on Sundays even though other stores throughout the town were permitted to stay open.

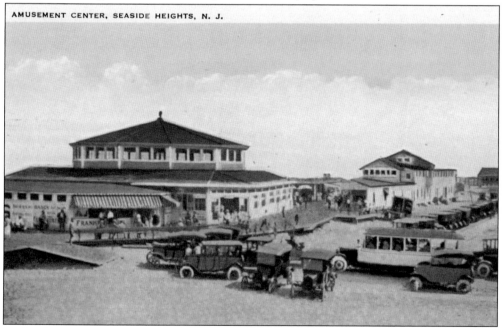

AMUSEMENT CENTER, SEASIDE HEIGHTS, N. J.

Under the management of F. H. Freeman, the Amusement Center pavilion added a bathhouse and Haag's Ice Cream concession, as shown in this scene.

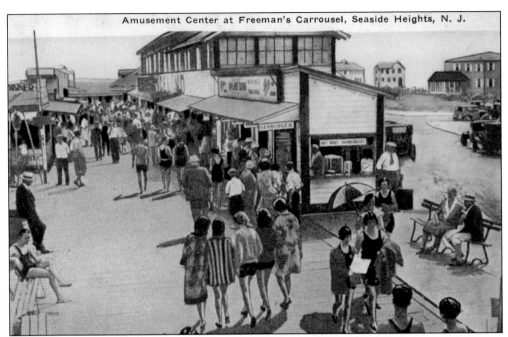

As the beach adjacent to Freeman's Amusement Center filled up with bathers, business-savvy people realized that the vacationers would have to be fed. Food concessions quickly sprang up on the boardwalk between Dupont and Porter Avenues to satisfy the appetites of thousands of weekly visitors. Whether one was in the mood for a hot dog or a home-cooked meal at one of the sit-down restaurants, the boardwalk concessions pleased.

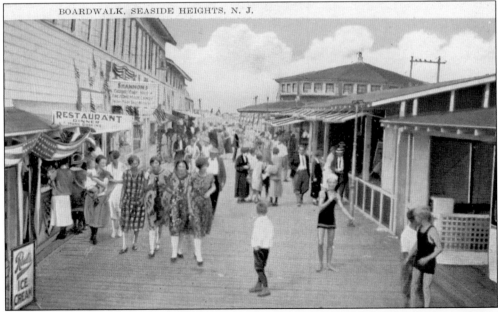

BOARDWALK, SEASIDE HEIGHTS, N. J.

In this photograph, two young boys wearing their bathing suits stand out among the crowd of boardwalk strollers. A sign for Shannon's Confectionary Shop hangs over the boardwalk and advertises homemade candy and fresh-made saltwater taffy. Another sign at the left bottom corner of the postcard advertises Red's Ice Cream.

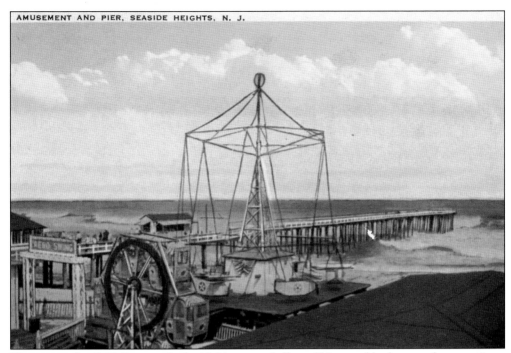

The success that F. H. Freeman had with his carousel allowed him to add other popular attractions, such as the Aero Swing and Kiddie Ferris Wheel.

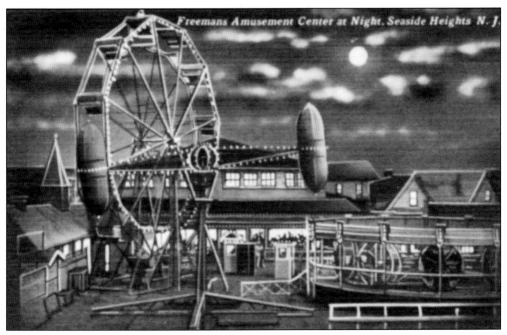

Freeman's Amusement Center is illustrated in this evening scene under a summer moon glowing through passing clouds. Boardwalk space was a valuable commodity then as it is today. F. H. Freeman knew that installing three amusement rides as close together as space and safety permitted would produce a greater profit than only one or two rides in the same space.

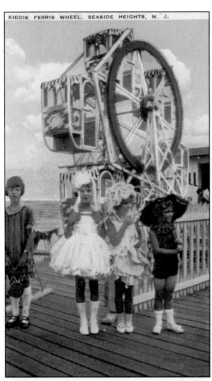

The Kiddie Ferris Wheel was a popular attraction at Freeman's Amusement Center. The wheel, with six caged cars, could have been built by the Pinto Brothers or William F. Mangels of Coney Island, both of which were prominent in the amusement ride industry during that era. Note the horse on the beach behind the young girls.

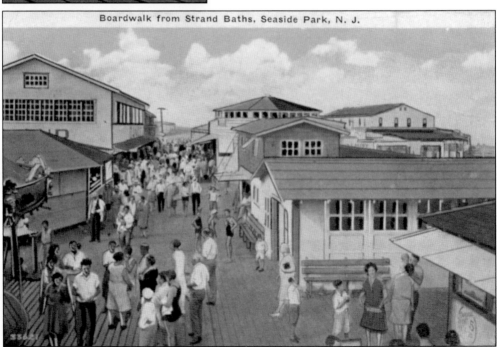

Boardwalk from Strand Baths, Seaside Park, N. J.

This is a view of Freeman's Amusement Center and Danceland from the Strand Baths in Seaside Park. A second carousel that gave the boardwalk its character and charm during this era is partly visible on the left side of the postcard. This merry-go-round, known as the Strand Carousel, was made by the Philadelphia Toboggan Company.

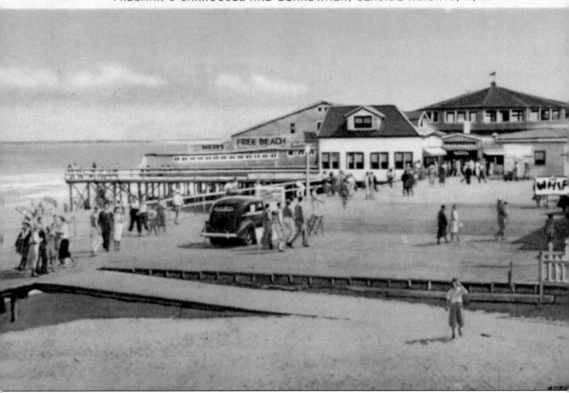

The automobile raffle stand seen in the center of this card was part of a tradition that started soon after the first wooden planks were laid. Over the years, the Seaside Heights Volunteer Fire Company, Tri-Boro First Aid Squad, Our Lady of Perpetual Help Church, and numerous social organizations have taken advantage of the throngs of summer visitors to raise funds by selling chances on automobiles, motorcycles, and boats.

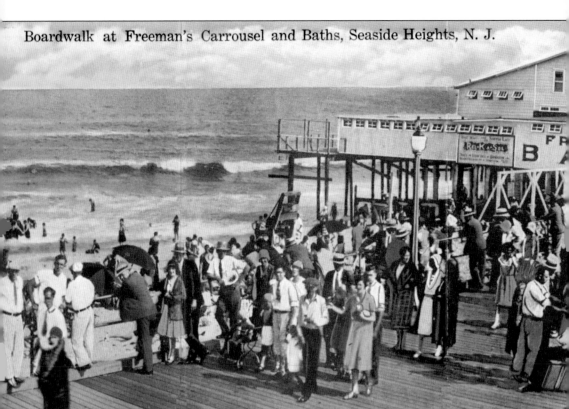

This 1930s scene of Freeman's Carousel and Baths faithfully preserved the spirit of the era. One can gaze deep into this photograph and imagine these visitors coming to life. Almost audible is the steady hum of the crowd's conversations and laughter, mixed with the rhythmic sound of seawater lapping on the shore. Above the knock of wooden balls and bells out of the skee-ball parlor, the carousel's two band organs can be heard playing minutes-long concerts using a

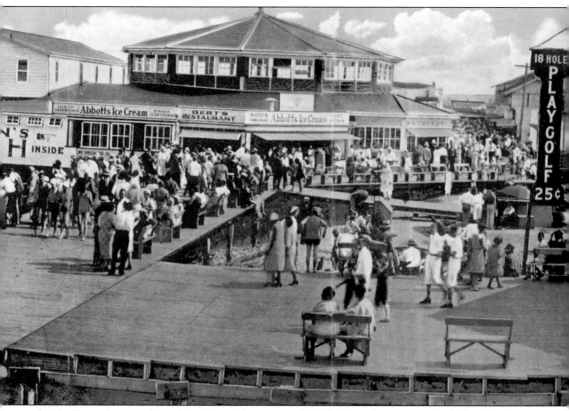

mechanically orchestrated combination of drums, cymbals, bells, and organ music. A line forms at the golf stand, where the course is busy with amateur golfers who are carefully aiming their balls through challenging obstacles. Further south, crowds of boardwalk strollers patronize the stores and food establishments. The avenue is lined with automobiles, and there is scarcely any place to park.

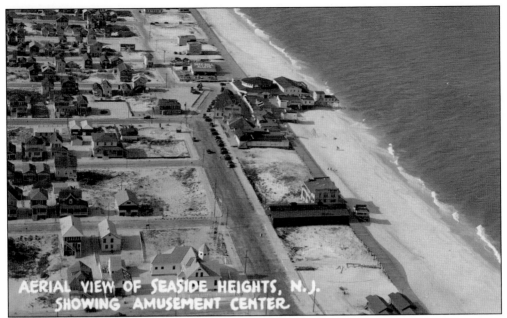

This aerial view was taken at a time when much of the oceanfront remained undeveloped, despite the unhindered construction of homes west of the ocean block. The Coast Guard Life Saving Station No. 9, at the bottom of the postcard, is located on Decatur Avenue in Seaside Park. Skee-Ball Alleys and Lee's Baths can be seen north of Freeman's Amusement Center.

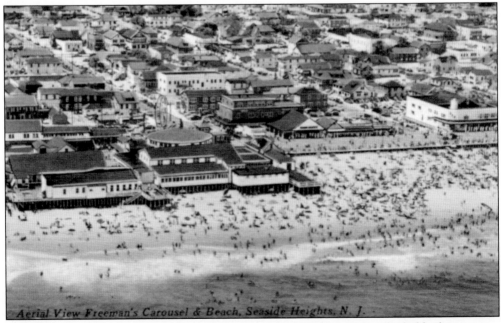

Over the years, Freeman's Carousel would survive many nor'easters, but the hobby horses were almost lost in one particular gale that hit the New Jersey coast in April 1929. The main center pole and numerous pilings were undermined and gave way, causing the pavilion to sag and shift away from the boardwalk. Firemen, joined by Coast Guardsmen, braved the rain and wind and drove new piles beneath the structure through holes that were sawed into the floor.

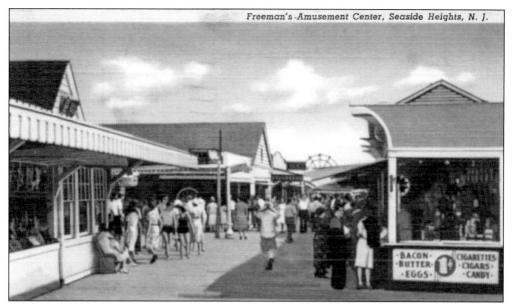

In 1957, two state supreme court decisions outlawed boardwalk games of chance and skill games. Owners were forced to convert their games to retail establishments or food stands. Mayor J. Stanley Tunney helped secure legislation to legalize the games. The bill passed through the legislature and was approved by an overwhelming majority during a statewide public referendum in 1959. The law restricted the price of games to 25¢ and the maximum amount a business owner could spend on a prize to $13.50. These limits were not cause for alarm in 1959, when most games were still a nickel or a dime and typical prizes won by vacationers were butter, bacon, eggs, cigarettes, bread, and other staples. In 1983, however, with competition from Atlantic City casinos decimating boardwalk businesses along the Jersey coast, a new law increased the maximum price of games to $1 and the maximum amount an owner could pay for a prize to $600.

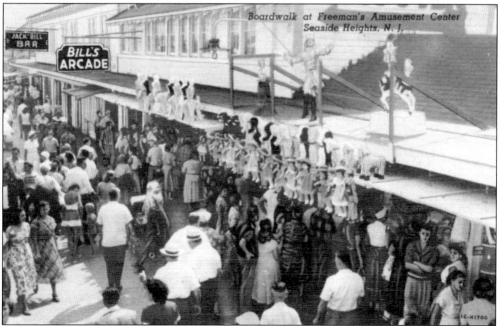

Boardwalk at Freeman's Amusement Center Seaside Heights, N. J.

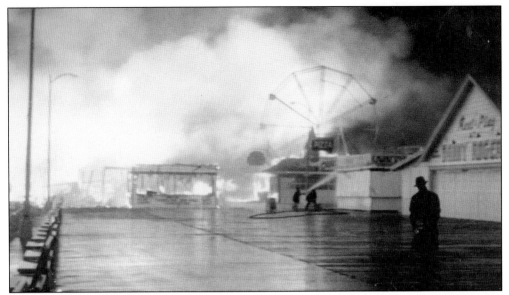

The first major fire to strike the boardwalk was reported by the watch at the Coast Guard tower at approximately 6:00 a.m. on June 9, 1955. The fire raged out of control for over two hours, whipped by 50-mile-per-hour northeast winds. Eleven firefighting units from surrounding towns, including firefighters from the Naval Air Station at Lakehurst, courageously fought the blaze. (Courtesy of Megan Brady.)

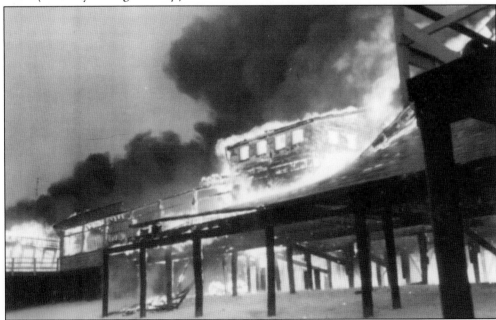

By the time the conflagration was extinguished, the flames had claimed the 75-foot-long fishing pier, nearly 80 boardwalk stands, the Ferris wheel, the roller coaster, Jack and Bill's Bar, the Beachcomber Bar, and the Red Top Bar. Perhaps most heart-wrenching to locals and vacationers was the loss of the Dentzel/Muller carousel. There simply was no way to measure the anguish of losing that boardwalk landmark. (Courtesy of the Seaside Heights Volunteer Fire Company Museum.)

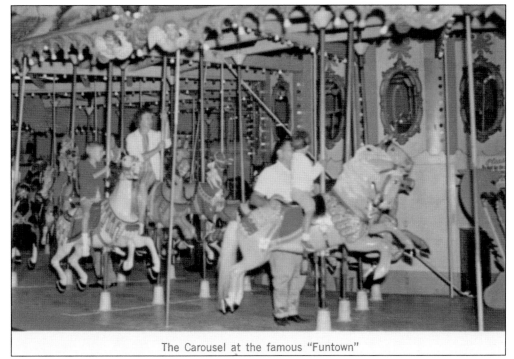

The Carousel at the famous "Funtown"

Mayor J. Stanley Tunney, who had been managing and investing in Freeman's Amusement Center since F. H. Freeman's death in 1935, purchased the four-abreast 1917 Illions carousel in this postcard as a permanent replacement. Tunney found the merry-go-round in Coney Island and paid $22,000 for it. He spent another $20,000 to rebuild the machine and repaint its 64 animals. Sadly, in 1990 the carousel was broken up and sold to collectors at auction.

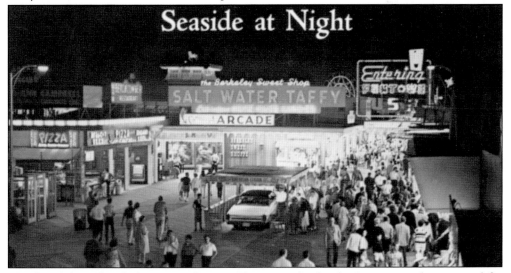

The fire did not break the spirit of Mayor Tunney and other businessmen, who operated for the season out of temporary stands on the east side of the boardwalk. As reconstruction ensued, however, Tunney set his sights on building Funtown U.S.A., a consortium of businessmen that would develop a new major amusement center on the south end to compete with the flourishing Casino Pier. Funtown U.S.A. opened in the spring of 1957.

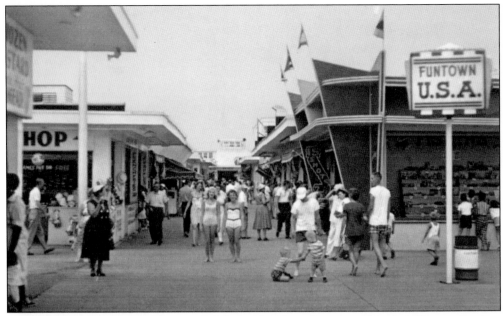

Funtown U.S.A. was an impressive accomplishment for Mayor Tunney and his band of concessionaires. The Seaside Heights boardwalk now offered vacationers a second major amusement park.

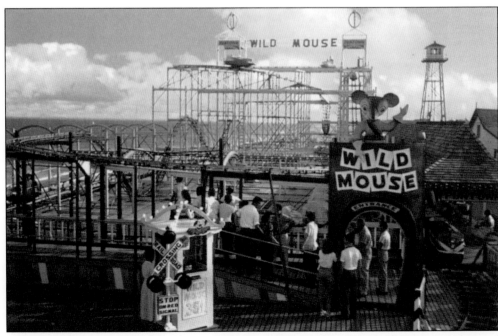

This Wild Mouse ride, the first roller coaster on the Seaside Heights boardwalk, was manufactured by B. A. Schiff and Associates of Miami, Florida. It was installed at Funtown U.S.A. in 1957.

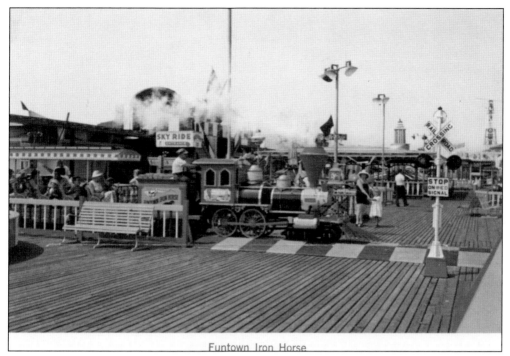

Funtown Iron Horse

The Funtown Iron Horse was advertised as "A bit of early Americana which travels the length and breadth of Funtown. One of the most popular attractions for young and old." A railroad crossing signal backed up by the Iron Horse's bell warned parents and children that the train was nearing the crossing.

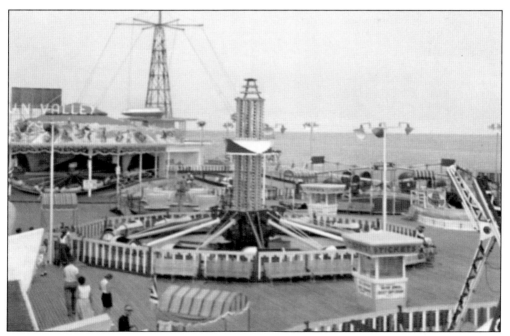

This postcard shows some of Funtown's other early attractions, such as the Rocket Ship Swing, Sun Valley Bob, Tilt-A-Whirl, Fly-O-Plane, and Crazy Cups.

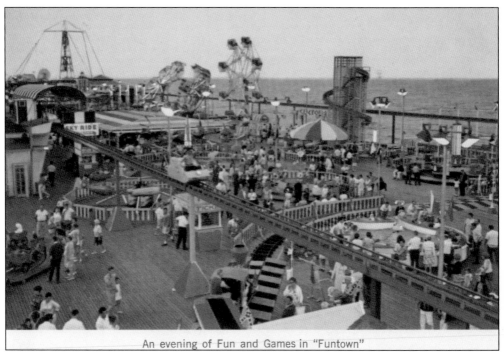

An evening of Fun and Games in "Funtown"

The Sky Ride monorail, manufactured by the Allan Herschell Company, was erected at Funtown U.S.A. in the early 1960s. The ride transported guests in four-passenger cars along a quarter-mile track that was elevated over many of the park's rides.

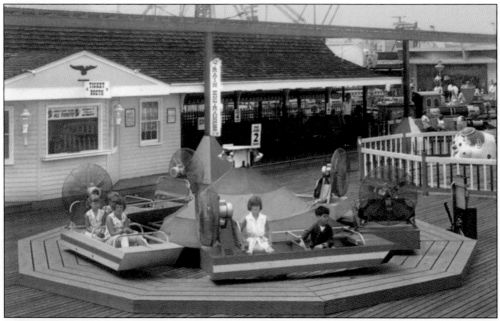

Although a ride on these faux air boats probably was not nearly as thrilling as a trip on the real thing through the Florida Everglades, rides similar to this one, using imagination as their engine, take their place on the Funtown Pier each year. Funtown has evolved into one of the Jersey Shore's premier amusement centers.

Nine

SEASIDE HEIGHTS CASINO AND POOL

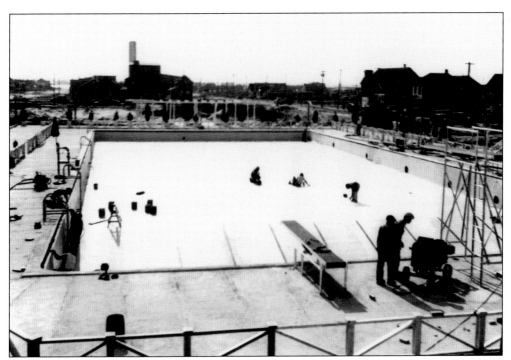

Linus Gilbert appeared on the scene in 1932 in search of a site for a carousel he had purchased and renovated. He acquired the property between Grant and Sherman Avenues, extending from the ocean to the Boulevard. Unable to effectively compete against the more established Freeman's Amusement Center, Gilbert started to expand the business in 1937 by adding the 165-by-65-foot swimming pool shown in the above photograph. (Courtesy of Leonard Ipri.)

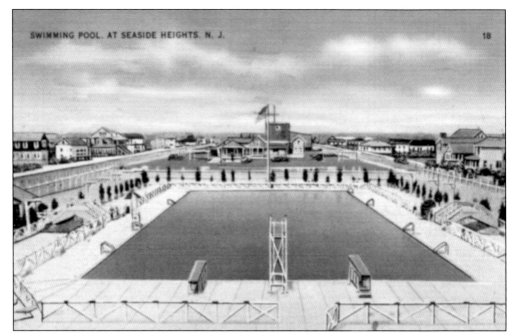

The pool was advertised as the largest recirculating, chlorinated saltwater swimming pool in the country and was a major attraction until it was demolished in 1986 as part of plans for Water Works, a 2.3-acre network of small pools, a shallow canal—the Lazy River—with rubber tubes that wound halfway around the park's periphery, and nine enormous water slides.

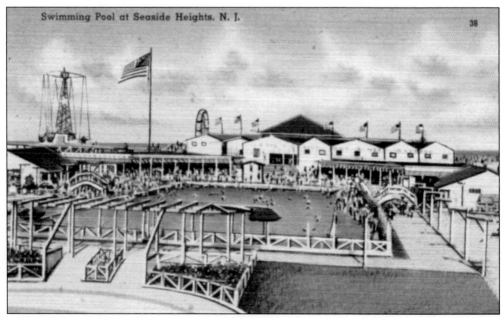

Swimming Pool at Seaside Heights. N. J.

38

This east-facing view of the swimming pool shows other features of the expansion, including the large exhibition hall, which contained games, concessions, and a ballroom, and the Swing ride and Ferris wheel.

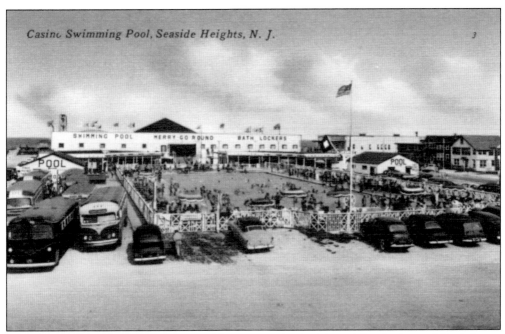

Casino Swimming Pool, Seaside Heights, N. J.

Linus Gilbert's expansion was a remarkable success. The Seaside Heights Casino and Pool almost instantly evolved into a major amusement complex anchoring the town's north end.

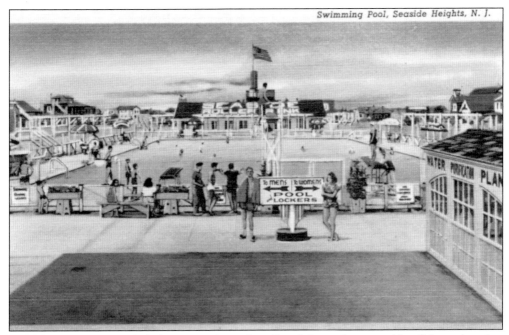

Swimming Pool, Seaside Heights, N. J.

The expansion also included construction of a roller rink on the west side of the swimming pool, as seen in this postcard and in the aerial view on the following page.

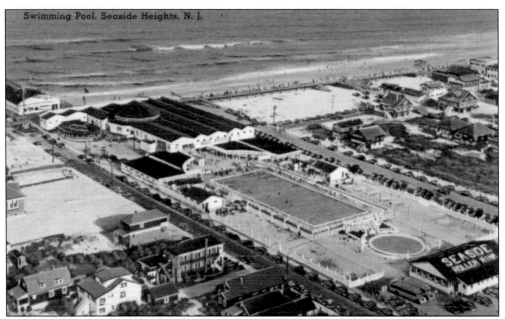

This view shows how sprawling the Casino site was after the 1937–1938 expansion. Sherman Avenue, running east-west, is on the north side of the amusement complex, and Grant Avenue is on the opposite side. What had once been the location of a thriving fish pound that sold daily catches of fish at Baltimore, Philadelphia, and New York City markets became a renowned venue for swimming, ballroom dancing, and playing games of chance.

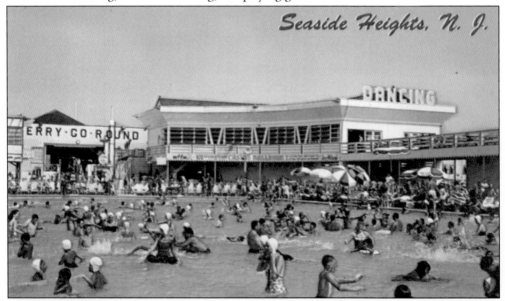

Advertisements for the Seaside Heights Casino and Pool in the early 1950s invited guests for "Fun and Frolic." Promising "Glorious Days!" and "Gala Nights!" the amusement center had something for everyone: water ballet shows, kiddie rides, nightly dancing, a penny arcade, a 300-person capacity seafood restaurant, nightclub, shooting gallery, miniature golf, and merry-go-round. The Olympic-size swimming pool, illuminated by colorful underwater lighting, was even open in the evening hours.

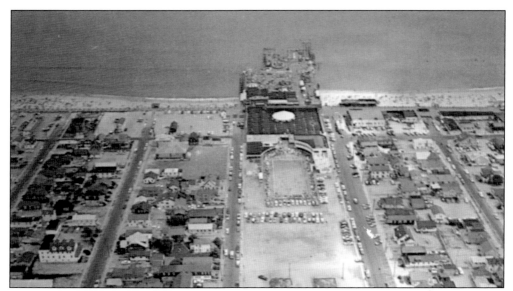

To keep the attention of vacationers, entertainment was hired from many parts of the country. During one summer season, for instance, the Billy Kehoe World Famous Water Show appeared nightly. The show featured high-diving champion Barney Cipriani from Miami, Florida, diving from a 110-foot platform, and high-jumping clown Boe. In 1953, water ballet lessons were given by a synchronized swimming instructor who had performed at Silver Springs and Cypress Gardens, Florida.

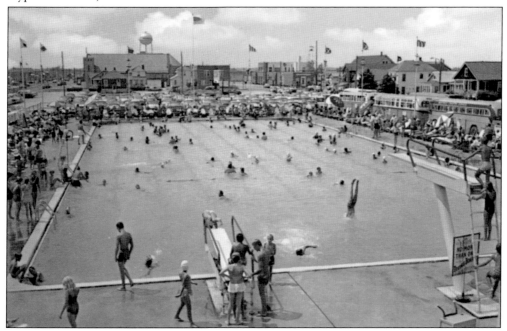

Large numbers of buses and automobiles from New York, Pennsylvania, and other far away places often filled the Casino's parking lots. But the pool was also popular among locals, who could buy a season ticket for $10 in 1952. In 1953, the Seaside Heights Volunteer Fire Company sponsored a water cavalcade fund-raiser with swimming and diving exhibitions performed by the Seaside Heights Beach Patrol and entertainers specially hired for the benefit.

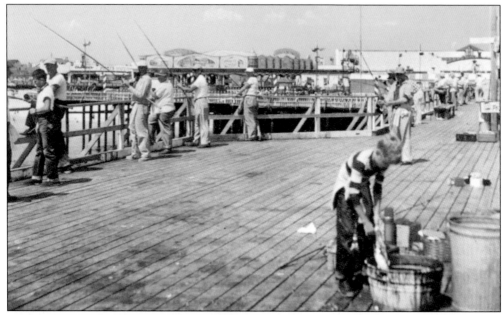

The fishing pier has survived treacherous hurricanes and nor'easters over the years, even though it had to be rebuilt after numerous thrashings by the wind and waves. One such storm in 1952 destroyed the fishing pier, but it was reopened in May 1953 with a 100-foot extension into the ocean. Many fishermen have caught their first bluefish or shark from the Casino's fishing pier.

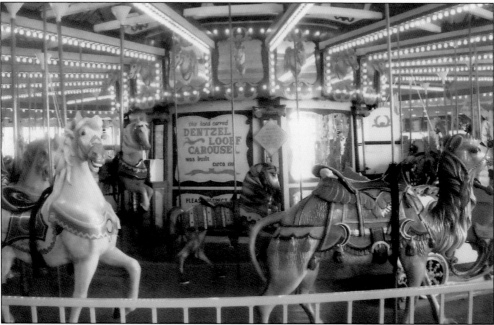

The carved figures and 1923 Wurlitzer band organ that comprised this Dentzel/Looff carousel when it arrived in Seaside Heights in 1932 still stand in the same spot at today's Casino building. In 1986, the carousel was named the Dr. Floyd L. Moreland Dentzel/Looff Carousel in honor of the classics professor from the City University of New York who saved the carousel from being auctioned in 1984 and personally oversaw its restoration.

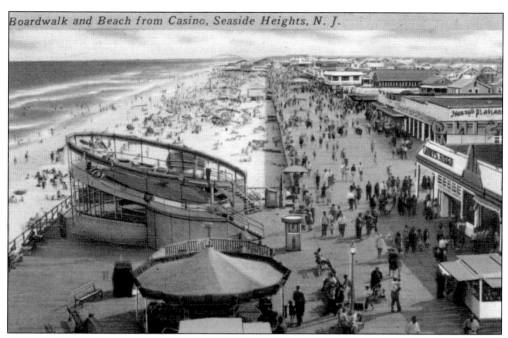

Boardwalk and Beach from Casino, Seaside Heights, N. J.

The magnitude of the riparian rights purchased with the property by Linus Gilbert is demonstrated by the two rides located on the extended boardwalk east of the Casino building. This was just the beginning, as Gilbert and subsequent owners John Fitzgerald, John Christopher, Kenneth Wynne Jr., and Robert J. Bennett added rides and expanded the pier out over the ocean one section at a time.

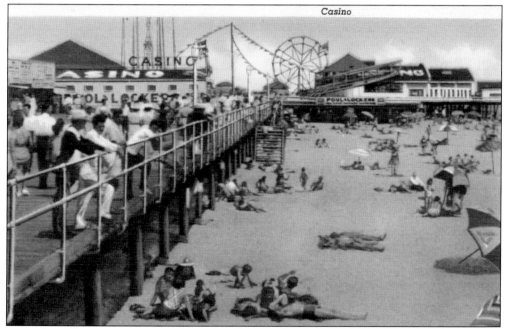

Casino

This postcard view shows the Casino building on the left and the nightclub on the pier behind some of the rides. The nightclub first operated as the Bamboo Bar, but it was known as the Parrott Club in the 1950s.

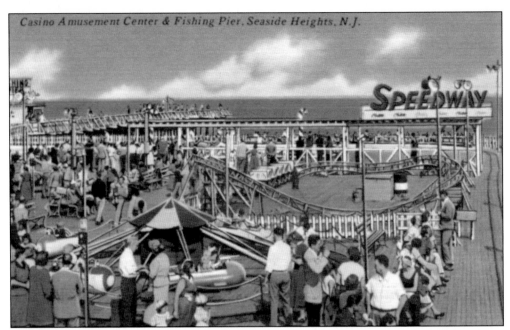

After extensive improvements were made to the amusement complex during the offseason, in May 1953, the Seaside Heights Casino and Pool opened with a new section of rides for adults and children, including a hot rod ride with cars imported from Germany. The ride in the foreground of this postcard allowed children to sit in a miniature fighter airplane and manually ascend and descend while engaging in mock air combat with the other airplanes.

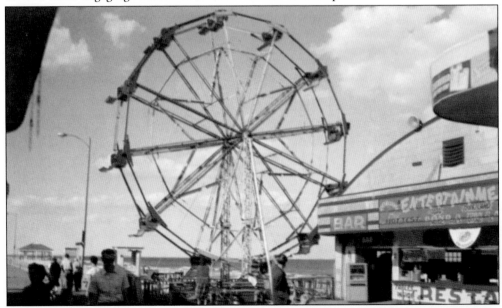

This small Ferris wheel was installed next to the Casino Pier building that housed the original Bamboo Bar and then the Parrot Club. The boardwalk north of the ride was still mostly residential in character at that time. That changed, however, when owners of the Casino Pier agreed in the early 1980s to sell the town a right-of-way through their property that would link the northern and southern sections of the town.

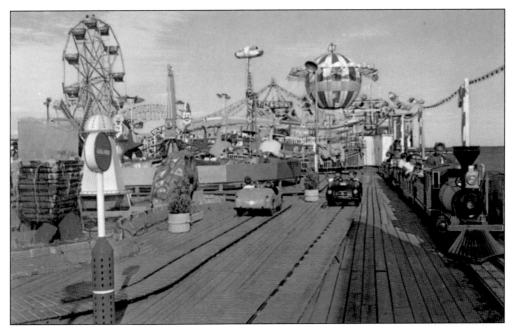

This view shows a section of the Casino Pier after Kenneth Wynne Jr. took over his father-in-law, John Fitzgerald's, interest in the business. A U.S. Navy veteran and University of Connecticut Law School graduate, Wynne quickly learned the business and is credited with bringing the most state-of-the-art thrill rides to the Casino Pier. Wynne traveled regularly to Europe in search of more and more popular attractions that he could introduce in the United States.

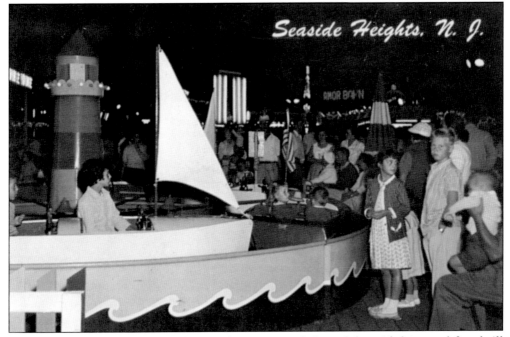

Although Casino Pier has been known for accommodating adults with large and fast thrill rides, the Casino Pier's owners have always made sure to include plenty of kiddie rides, such as this boat ride.

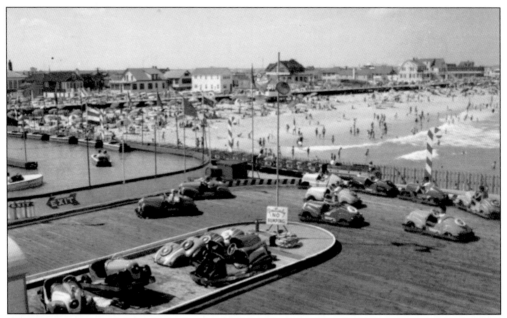

The residential character of the boardwalk north of Casino Pier, as shown here, changed substantially after a section of the Casino building was demolished in 1982 for the Ocean Terrace Avenue extension. Today the north end is virtually indistinguishable from the rest of the boardwalk, with the Aztec Motel, numerous arcades, scores of food stands, a restaurant with an ocean view, bars, and retail stores.

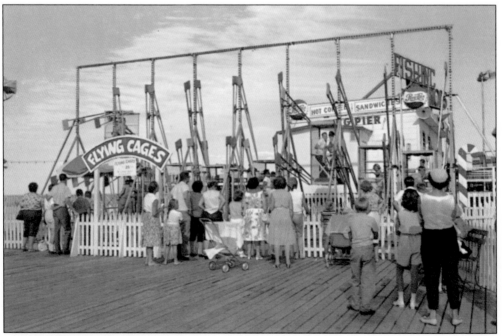

The Flying Cages was unusual as far as boardwalk rides go, in that it required riders to use their own physical strength. One or two riders entered the cage and swayed from side to side until the cage gained momentum and reached its peak height.

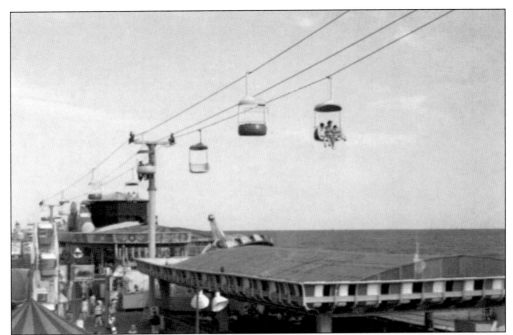

The Sky Ride was first introduced in 1964 and was modeled on ski resort chairlifts of the era. The ride transported passengers over the amusement complex to the swimming pool and back. The Sky Ride was ruined in the 1965 fire (see page 110) but was replaced in the late 1960s. In 1982, the ride was dismantled and removed due to the expansion of Ocean Terrace Avenue.

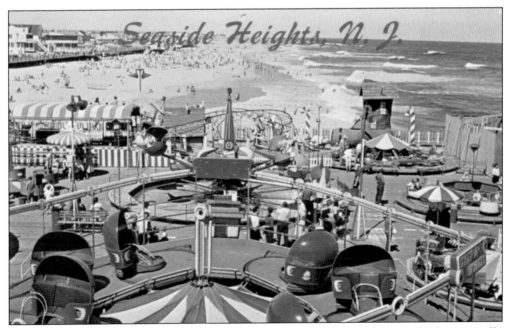

The Tilt-A-Whirl has been a crowd pleaser for many decades and is one ride that typically survived the regular rotation of old rides for new rides.

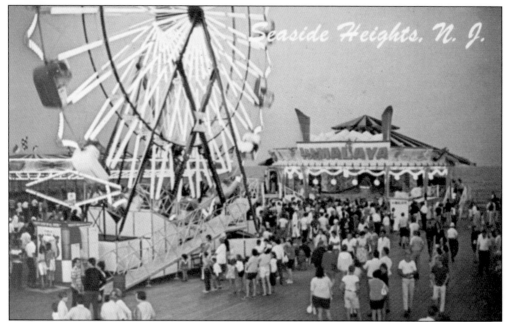

Casino Pier owner Kenneth Wynne Jr. established many fruitful relationships with European ride manufacturers. One relationship in particular, with a European ride broker named Edward Meier, led to the American debut of the Himalaya ride at Casino Pier in 1963. The ride was a sinuous train of open sleds that traveled round and round while loud music played, reaching a speed of up to 50 miles per hour.

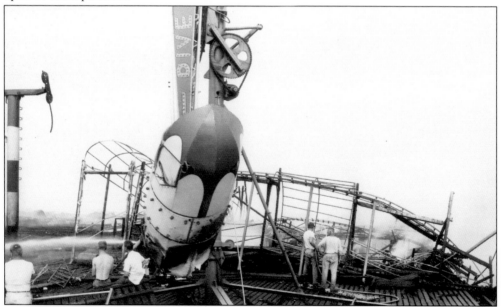

On June 10, 1965, one day following the 10th anniversary of the Freeman's Amusement Center fire, an inferno fanned by a stiff land breeze razed the seaward portion of the Casino Pier. The fire caused nearly $2 million of damage and destroyed eight rides: the Himalaya, Italian Ferris Wheel, Sky Ride, Dive Bomber, Wild Mouse, Scrambler, Rotor, and the European Dark Ride. (Courtesy of the Ocean County Historical Society.)

Ten

BOARDWALK AND
BEACH SCENES

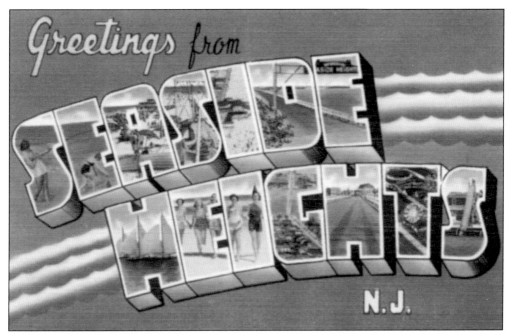

There were many different styles of "Greetings from Seaside Heights" postcards. In the above version, scenes from other Seaside Heights postcards were placed inside each of the letters. Some of those cards are presented in this book. Can you find them?

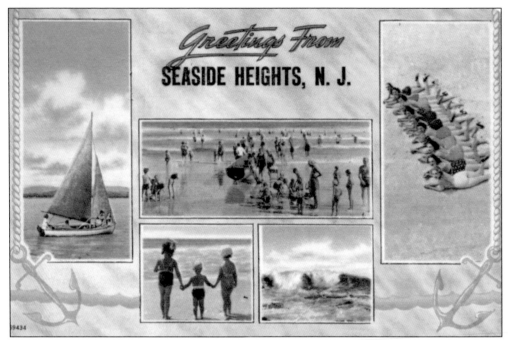

A message written on the back of a postcard that was mailed in 1967 stated, "Hi Mom and Dad. Having a great time. The weather is really beautiful. We're on the beach all day. Barb and Pat are really tanned. They've been having a great time talking me into the rides you wouldn't go on. See you 2 weeks. Love Jean, Barbara, Patty."

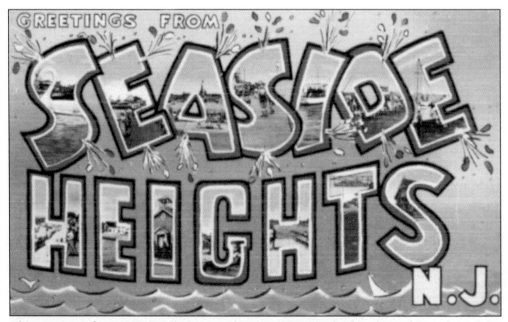

This greeting is from 1957: "Hello Mom and Henry. We arrived safe and sound Saturday at 3:30. We shopped and found a place for $55 a week. It's very nice. Scotty is down for the weekend. We are living at 252 Barnegat Ave. Seaside Heights, NJ. We are going to the boardwalk for awhile. Hope you are feeling well. Love Olive and Bill."

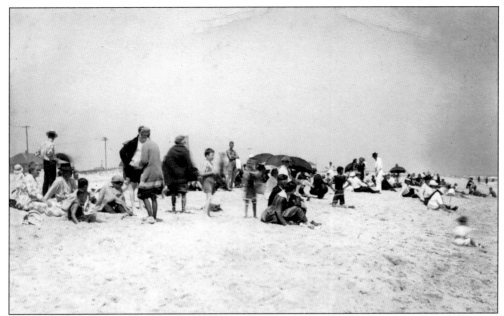

Walter Gillam, a local photographer who also worked at the fishery, was responsible for taking many of the great early photographs of Seaside Heights. This photograph was taken of bathers at the oceanfront at a time when visitors were drawn to the town solely for its sand, surf, and sun.

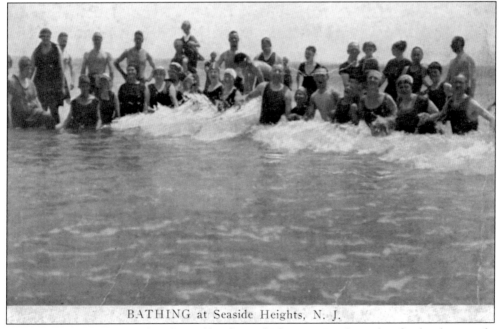

BATHING at Seaside Heights, N. J.

The bathers in the back row found a sand bar from which to position themselves for the photograph. Notice how the people in the front row are standing, yet they are the lower.

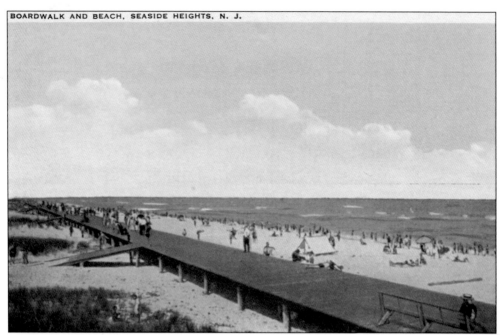

A woman who signed her name "L" wrote the following message to her husband, Enoch, in Trenton, New Jersey: "Dear Hubby. Having quite a nice time. I have some appetite. Bed just as soft as ever. Had a little visit by mosquitoes last night. We're talking of going somewhere tomorrow but don't know where yet. Hope you are well."

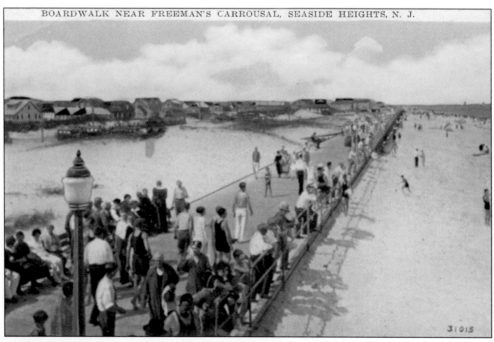

By the time this photograph was taken, the borough council had finally resolved problems in acquiring the rights-of-way it needed to construct the boardwalk. This view faces north from Freeman's Carousel before the time of arcades, food stands, games, and rides.

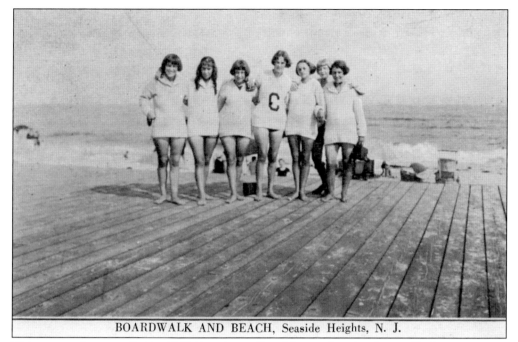

BOARDWALK AND BEACH, Seaside Heights, N. J.

This postcard was mailed in 1923 from Russell to his grandmother in Medford, New Jersey. Probably referring to the young ladies he had seen on the beach, or the girls on the postcard, he conveyed his thoughts in one brief sentence: "Class but not style Grandmother."

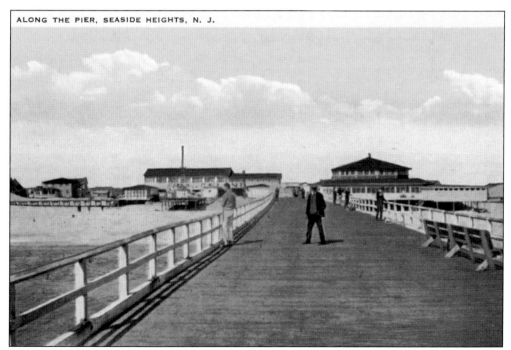

ALONG THE PIER, SEASIDE HEIGHTS, N. J.

There are many wonderful postcards that show the fishing pier at Freeman's Amusement Center. This particular card looks down the pier toward the carousel pavilion and Danceland.

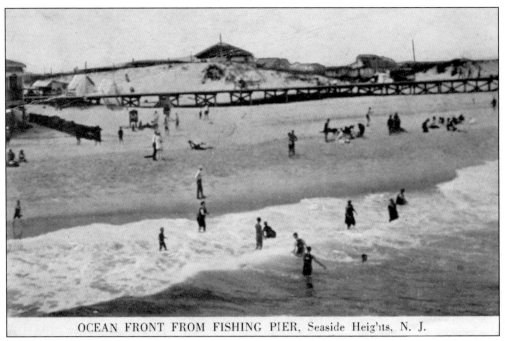

OCEAN FRONT FROM FISHING PIER, Seaside Heights, N. J.

In this real-photo postcard a food stand is visible near the large dune behind the boardwalk. Note the tents next to the stand, where the vendor slept and stored his personal belongings for the summer season.

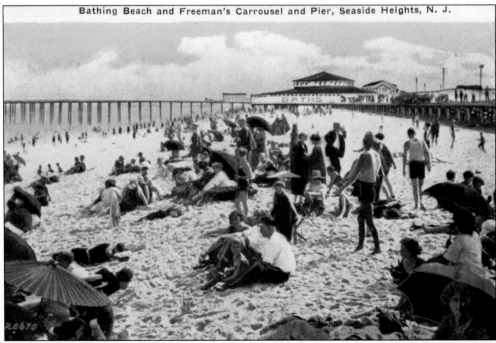

Bathing Beach and Freeman's Carrousel and Pier, Seaside Heights, N. J.

The sender of this card was staying at the St. Charles Hotel in 1923: "Got your letter this morning. This is where we are stopping. Saw the big air ship at Lakehurst yesterday. Cold here, too. Have not had a dip so far. I'm afraid of my ear. Love Ed."

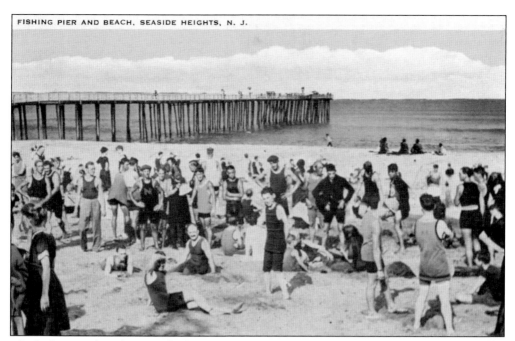

FISHING PIER AND BEACH, SEASIDE HEIGHTS, N. J.

The bathers in this photograph obviously are aware of the photographer's presence. With the fishing pier at Freeman's Amusement Center as the background, this scene is reminiscent of an average day during this timeless era.

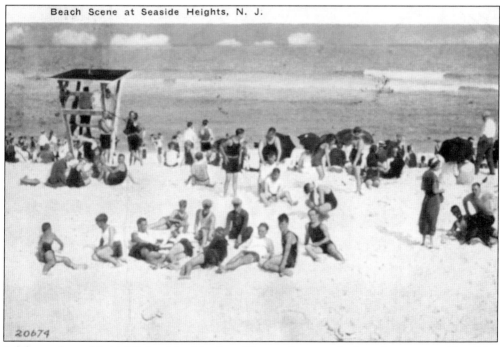

Beach Scene at Seaside Heights, N. J.

A lifeguard stand is highlighted in this view. The sender remarked on the message side of the card, "Hi folks! Everything here is lovely—the beach, water and weather but especially the merry-go-round. See you soon. Lynne."

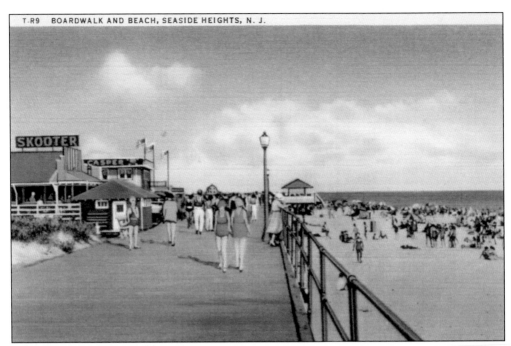

Skooter and Casper's Bathing Pavilion were located on the boardwalk in the vicinity of Sumner Avenue. Further north past these two establishments, a small pavilion with benches was constructed on an extended portion of the boardwalk for shade and temporary shelter from the rain.

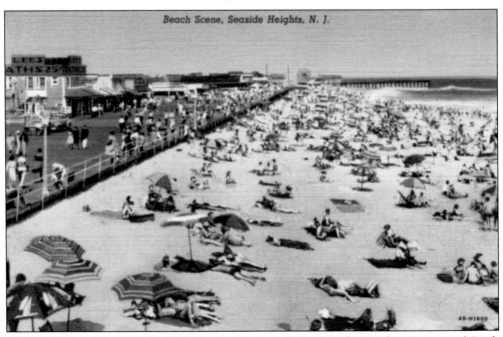

This is a view of the boardwalk facing north toward the Seaside Heights Casino and Pool. Numerous concessions had opened on the boardwalk when this photograph was taken.

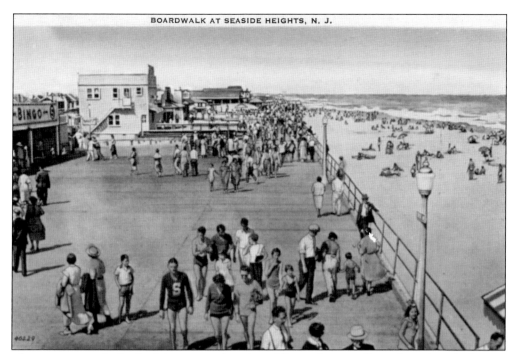

The message on the back of this postcard reads as follows: "Dear Billy and Cookie. I'm having a swell time and getting a nice coat of sun tan. The water has been very safe and cold, but nice after you get wet. Be good and listen to mother. I'll see you soon. Your Aunt Gertrude."

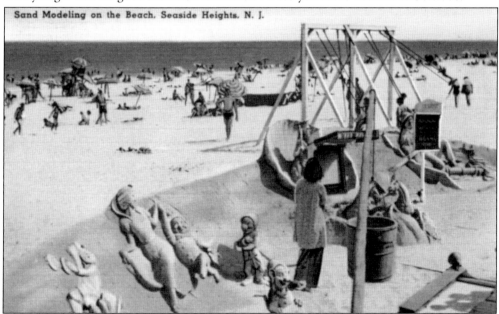

Sand Modeling on the Beach, Seaside Heights, N. J.

This card was mailed to Sgt. John J. O'Grady, USMC, at the U.S. Marine Air Station, Cherry Point, North Carolina, on August 20, 1945. "Dear Johnny. Finally on vacation and am enjoying every minute. Good swimming. Quite a few amusements and the night life isn't bad. Nothing too rowdy thank heaven. Expect to learn bicycle riding while I'm here. We went to the beach twice today and I'm as red as a fire engine. Love, Catherine."

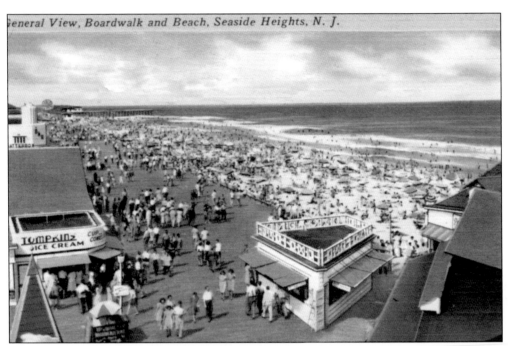

The beach is dotted with bathers and umbrellas in this view. Many locals and vacationers can recall summers when the beach was so crowded that one would have to arrive early in the morning to guarantee a space for one's towel or umbrella.

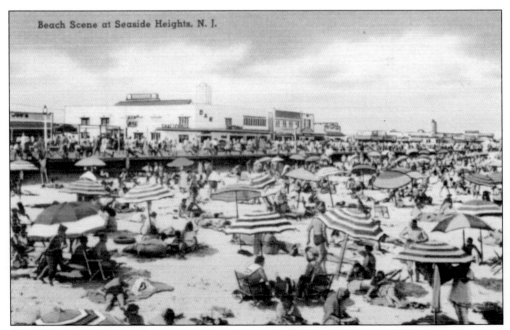

The Chatterbox Bar is a reference point in numerous Seaside Heights postcards. The bar was owned by the Olson family for many years and was located on the Boardwalk at Lincoln Avenue.

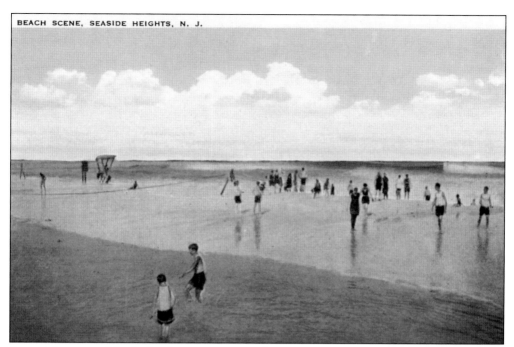

An article appeared in the local newspaper on July 31, 1931, reporting that a suitless bather had been apprehended. The woman defended her action by stating that she saw no signs on the beach forbidding bathing in the nude. "Signs or no signs," said the justice of the peace, "you know we are not living in the days of Adam and Eve." Note the rope line in this view that was available for safety purposes.

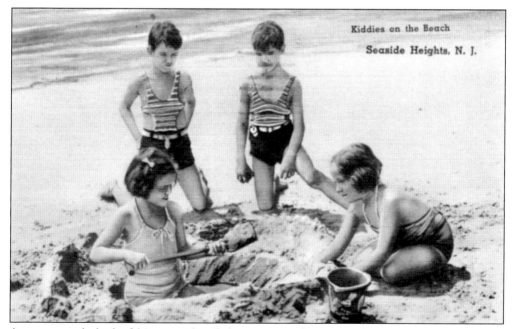

A message on the back of this postcard mailed to Norma Webster in Doylestown, Pennsylvania, reads, "Hello Norma. How would you like to play with these children in the sand? Aunt Mary."

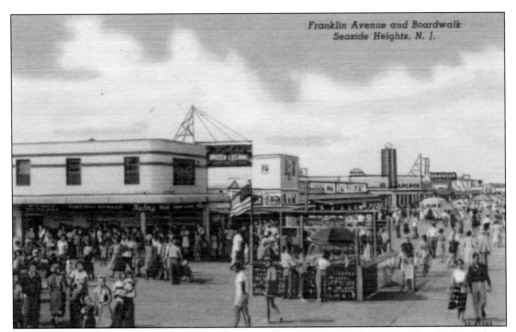

Kohr's Original Frozen Custard, located on Franklin Avenue and the Boardwalk, has a long history of selling ice cream on the boardwalk. Elton Kohr was one of three Kohr brothers from York County, Pennsylvania, who used a gasoline-powered ice cream machine in 1917 to invent their own creamy version of frozen custard. Elton decided to venture out on his own and, in 1923, opened his first frozen custard stand in Seaside Heights. The stand is owned today by the author's friend, Greg Kohr.

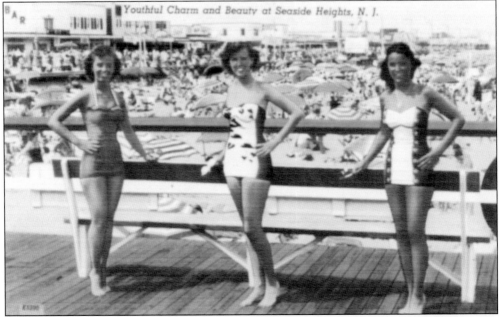

This postcard captures the youthful charm and beauty of three young ladies. The carousels are the indisputable soul of the boardwalk, but it has been said that bathing beauties are the soul of the beach.

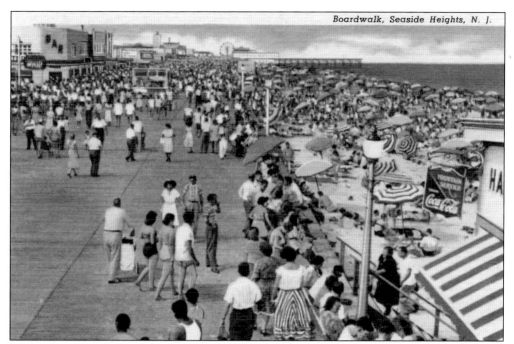

On this postcard, sender Muriel wrote, "Dear Bill. Do you miss your big sister? I know she misses you. We're having a wonderful time. We had your sister out bike riding yesterday, and does she feel it today! I really got burned yesterday. That was before we went bike riding. It's a good thing we went because it's best to move around so it won't get stiff on you. See you soon."

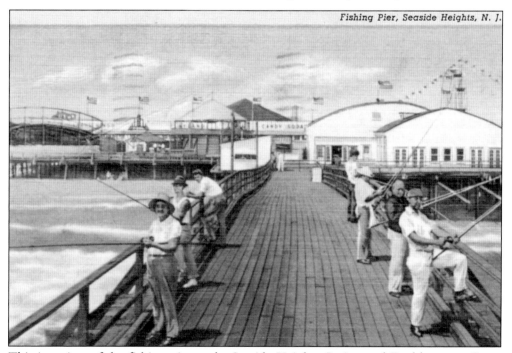

This is a view of the fishing pier at the Seaside Heights Casino and Pool between Grant and Sherman Avenues.

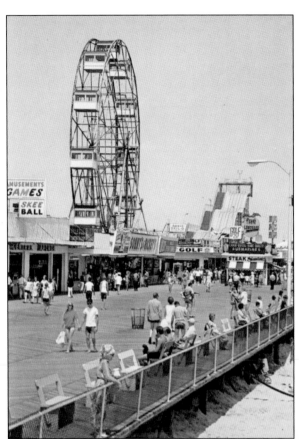

This postcard is not an illusion. This giant Ferris wheel and slide were really installed on the rooftops of arcades and food stands between Hamilton and Sumner Avenues.

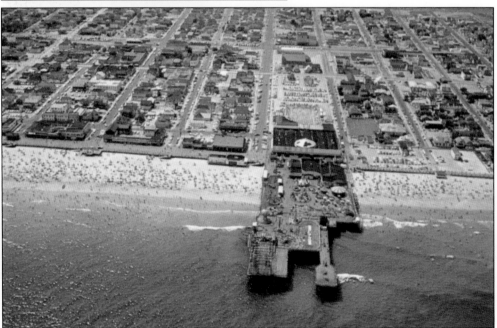

This aerial photograph shows the Casino Pier and almost the entire town of Seaside Heights.

"Pretty girls seem to be attracted to the red lifeguard T-shirt," stated lifeguard captain John Boyd in an interview given in the 1980s. Boyd was behind "The Voice" that could be heard daily from the boardwalk's loudspeakers, warning bathers against Frisbee tossing or describing a lost child who was being cared for at lifeguard headquarters. Boyd closed the beach each afternoon with the following words of caution: "Stay out, stay alive."

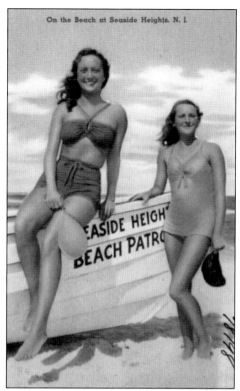

On the Beach at Seaside Heights. N. J.

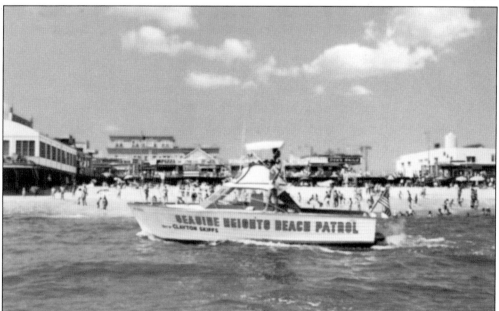

The *Miss Seaside Heights*, a lifeguard patrol boat skippered by Lt. Joseph Boyd, was docked at Pelican Island but powered its way daily through the Barnegat Inlet in order to take up its position guarding the Seaside Heights beaches. Another Boyd brother, Lt. Hugh J. Boyd Jr., who also served as the elementary school principal, was in charge of the lifeguards and eventually succeeded John Boyd as captain.

Appendix

SEASIDE HEIGHTS
POSTCARD PUBLISHERS

Ace Novelty and Printing, Carteret, New Jersey.

American Post Card Company, Brick, New Jersey.

Andres Prod. Corporation, New York, New York.

Arrow Advertising Specialty Company, Wanamassa, New Jersey.

Arrow Letter Services, Asbury Park, New Jersey.

Artvue Post Card Company, New York, New York.

Belle Freeman, Seaside Heights, New Jersey.

Belle Freeman Estate, Seaside Heights, New Jersey.

Bill Bard Associates, Monticello, New York.

Coronet Greeting Card Company, Elizabeth, New Jersey.

Curt Teich, Chicago, Illinois.

CT Greetings.

Dave Johnson, Toms River, New Jersey.

Dial Press Postcard.

E&D Stores, Inc., Seaside Heights, New Jersey.

Ess and Ess Photo Company, Inc. New York, New York.

F. H. Freeman, Seaside Heights, New Jersey.

Free Lance Photographers Guild, Inc.

George J. Block, Avon, New Jersey.

George M. Endres, Seaside Heights, New Jersey.

Harry Stock, Seaside Park, New Jersey.

John S. Conover, Seaside Park, New Jersey.

John Margolies.

Landis & Alsop, Newark, New Jersey.

Leo Peskin Studio, Lakewood, New Jersey.

Lynn H. Boyer, Philadelphia and Wildwood.

P. Sander, Philadelphia and Atlantic City.

Parlin Color Company, Toms River, New Jersey.

Parlin Color Photos Company, Toms River, New Jersey; Boynton Beach, Florida.

Parlin Photo Service, Toms River, New Jersey.

Post Card Shoppe, Seaside Heights, New Jersey.

Rose Sales Company, Asbury Park, New Jersey.

Samuel Strauss Company, Brooklyn, New York.

S. K. Simon, New York, New York.

Spalding Publishers, Chicago, Illinois.

(The) Albertype Company, Brooklyn, New York.

(The) Collotype Company, Elizabeth, New Jersey; New York, New York.

Tichnor Brothers, Inc., Boston, Massachusetts.

T. P. and Company, New York, New York.

Union Distributors, Inc., Red Bank, New Jersey.

Union Paper Company, Inc., Red Bank, New Jersey.

Walter Gillam, Seaside Heights, New Jersey.

William H. Cowdrick, Seaside Park, New Jersey.

BIBLIOGRAPHY

Anderson, Andrew J. *Seaside Park*. Charleston, SC: Arcadia Publishing, 1998.

Futrell, Jim. *Amusement Parks of New Jersey*. Mechanicsburg, PA: Stackpole Books, 2004.

New Jersey Courier, January 16, 1914–August 20, 1915

Ocean County Historical Society Vertical File: Seaside Heights (1913–2009).

Ocean County Review, January 1, 1915–December 27, 1940

Roberts, Russell, and Rich Youmans. *Down the Jersey Shore*. New Brunswick, NJ: Rutgers University Press, 1993.

Salvini, Emil R. *Boardwalk Memories*. Guilford, CT: The Globe Pequot Press, 2006.

The Carousel News and Trader 10 and 23 (April 1994, No. 4; and September 2007, No. 9).

Williams, Howard. *Tides of Time in Ocean County*. Toms River, NJ: Ocean County Principals' Council, 1940. Reprint Danbury, CT: Polyanthos, Inc., 1971.

Wilson, Harold F. *The Story of the Jersey Shore*. Princeton, NJ: D. Van Nostrand Company, Inc., 1964.

Wortman, C. Byron. *The First Fifty: A Biographical History of Seaside Heights*. 50th Anniversary Committee, 1963.

DISCOVER THOUSANDS OF LOCAL HISTORY BOOKS FEATURING MILLIONS OF VINTAGE IMAGES

Arcadia Publishing, the leading local history publisher in the United States, is committed to making history accessible and meaningful through publishing books that celebrate and preserve the heritage of America's people and places.

Find more books like this at
www.arcadiapublishing.com

Search for your hometown history, your old stomping grounds, and even your favorite sports team.